AMÉLIE CREMER & CARINA VON BÜLOW

THE
WEDDING
BOOK

Everything You Need to Know

teNeues

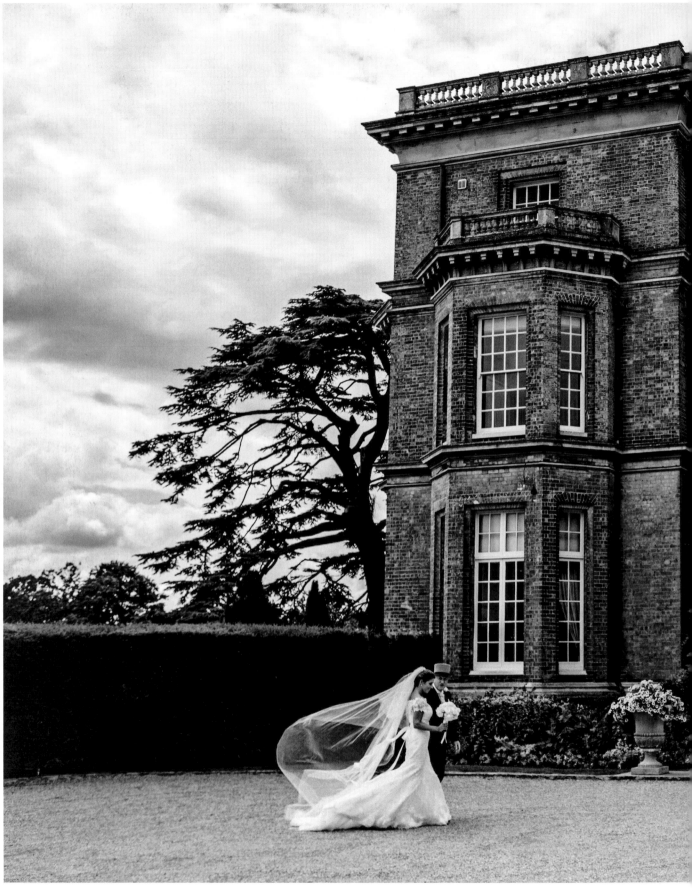

CONTENTS

FOREWORD

The opportunity to publish this book was a long-cherished dream that was, at the same time, as surprising and unexpected as a marriage proposal. As sisters and best friends, we have always been happy to work together on many shared ideas and projects, and have tried to create colorful, cheerful, and special projects. We already had some experience in organizing and co-designing weddings, but it was only through the planning of one of our own weddings that we became completely absorbed in this wonderful topic. The immeasurable diversity surrounding this special celebration—all of the myths, stories, and traditions—provided us with the most beautiful ideas for different ways to get married. The greatest and most incredible inspiration is, of course, love itself, as well as striving to reflect and make the things that render two people special tangible during the celebration.

This book is intended for those who dream of a wedding, regardless of whether it's in the near future or still just something you imagine for yourself. It doesn't matter where, when, how, or whom you marry, how young or mature you are, where you come from, or where you want to go. In the end, you should have the most beautiful wedding you can imagine. The period of planning and preparation is a special time and is particularly lovely, exciting, and precious, because it is the beginning of your celebration. The preparations are the path to your life together and a great opportunity to spend some unforgettable hours with each other.

You will not find the words "wedding stress" or anything that may cause frustration in our book. In fact, we want to provide you with practical and proven advice to make things a little easier and help you on your way to saying "yes." This book is intended to help all couples enjoy and savor the preparations with all of the senses. Here you will find ideas and inspiration and can consider whether the "do-it-yourself" trend might be something for you. Fall in love with all of the possibilities every day and look forward to your new life, which begins now—hand-in-hand, stress-free, and with the world's best celebration as the high point of your love.

Realize your true self, seize the day, and marry the love of your life!

Yours, Amélie Cremer and Carina von Bülow

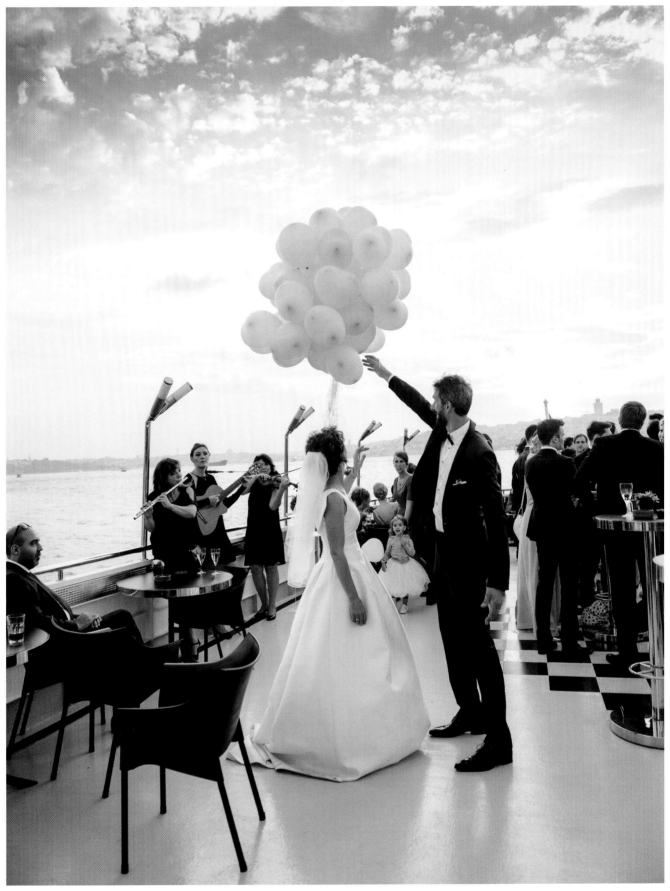

"Will you marry me?" These magical words change your life forever!

Our world is a wonderful place with an immeasurable wealth of moral standards and customs, superstitions, and traditions and a huge variety of people with different characters and backgrounds, desires, and fantasies. But no matter what country or culture, social class, or era you look at, for most lovers on this earth, their wedding is the most important celebration in their life. Admittedly, perhaps the ladies' opinion plays a slightly bigger role, but we are happy to forgive men for this. Once the question of all questions has been asked, everything revolves around the big event for the future husband as well, whether he wants it or not.

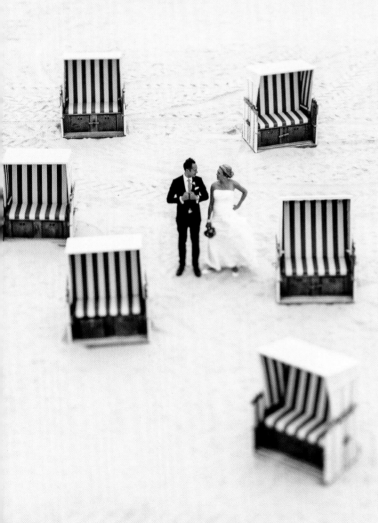

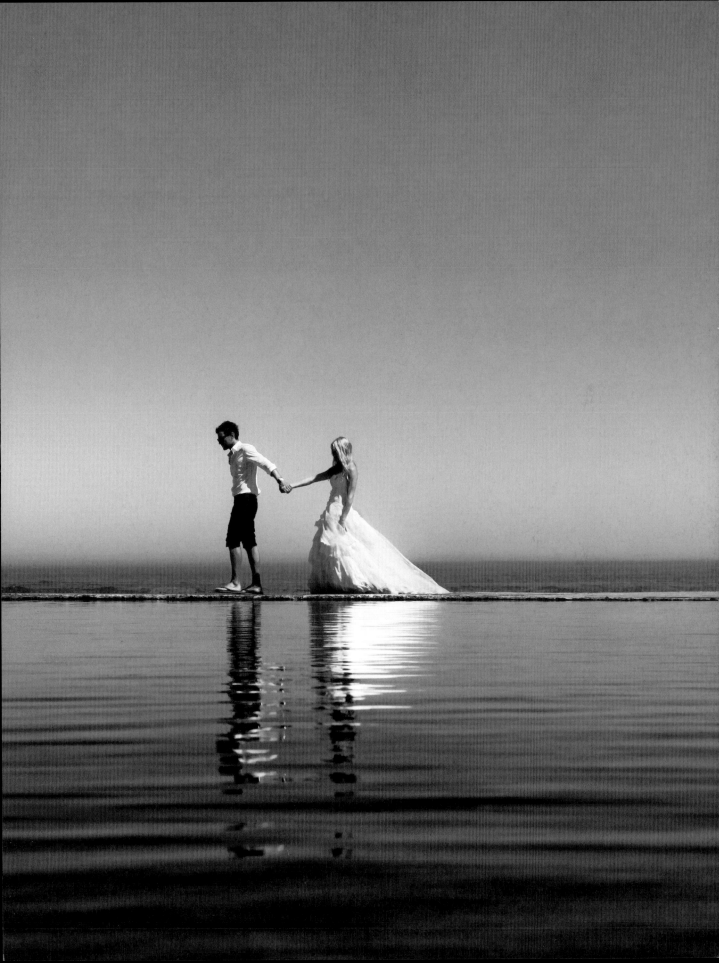

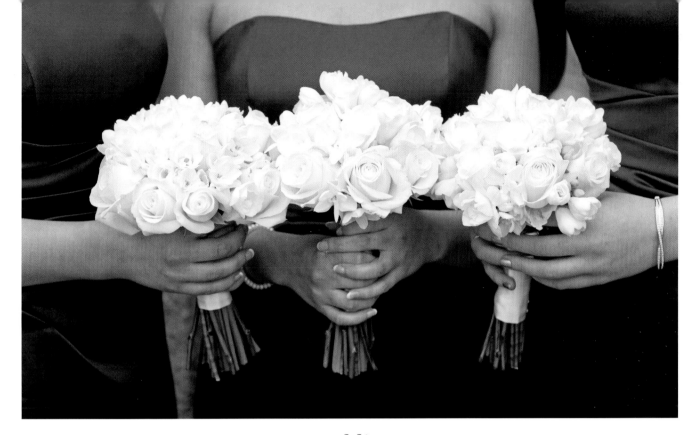

Wedding.
Where does the name of this big event come from?

Marriage appears for the first time in the Bible, where the eternal union is described as man and woman before God.

The term wedding dates back to the Middle Ages. Its Old English equivalent is *wīfung*, meaning "taking of wife." However, the earliest known word for the wedding ceremony is the Old English *brýdlóp* which can be translated as "bridal run." The word nuptials dates back to the late 15th century and is derived from the Latin *nuptiae, meaning* "wedding."

Marriage in turn comes from the Old French *mariage,* or if you look even further into the past, from the Latin *maritatus,* and describes the state of being husband and wife.

A single, clear etymological root or origin can no longer be determined, but all roads lead to Rome—or at least to tying the knot. In the end, the different meanings still focus on one central point: Two people's love for each other and the decision to share their lives and face their future together, in good times and bad.

A more beautiful and joyful celebratory occasion is hardly imaginable—so, with this in mind:
Let's get married!

Wedding stress?
These words don't exist (for us).

Of course, there is a great deal to be done, to take care of, plan, and choose, but this marks the beginning of your wedding and it is a wonderful feeling, a luxury. Enjoy this time full of anticipation and excitement. A wedding should be, will be, and will remain the most beautiful and memorable day for all participants and in particular for you, the bridal couple. Believe us, the actual wedding day will fly by all too quickly. This makes it all the more important that you enjoy and consciously experience the weeks of preparation and planning during the run-up, too. Many years later, you will remember both the big moments and the little ones, and these will hopefully bring a smile to your face. In order to ensure that it is a success, take one thing in particular: time. Approach the mountain of things to be done cheerfully and very calmly; after all, you really can't do anything wrong during the preparations. Don't put yourself under unnecessary pressure or set your expectations higher than you can afford, both financially and in terms of time. The joy and happiness of having found each other is the only prerequisite for a great celebration; everything else will take care of itself by and by, and you will find the best of help on these pages.

Anything is possible, but there is nothing you "must" do!
If you are getting married, you are allowed to wish for anything.

Weddings today are as individual as the bride and groom, and that is the wonderful thing about them. It is your day and your celebration. Your guests can and want to see and feel this. The more authentic your celebration's settings and arrangements and the closer you are as a couple, the more comfortable you will feel. Nobody remembers the most opulent celebration of all times, or the most elaborate dessert buffet the world has ever seen. Memories of a celebration that suit you and your style will last a lot longer.

Start thinking about it soon. You have said "yes" and this is something you both want. Cozied up over a bottle of wine, calmly discuss the essential questions. And a small tip for the prospective bride: His opinion is needed and should be listened to. Even if the message is still hidden between the lines, listen (as well as later on in the marriage)—you should both enjoy this day. "Don't you think a salmon-colored tuxedo would suit me?" doesn't mean that your beloved partner would really like to wear one. Hopefully.

YES, WE WANT TO!
Getting married should be one thing above all else—fun

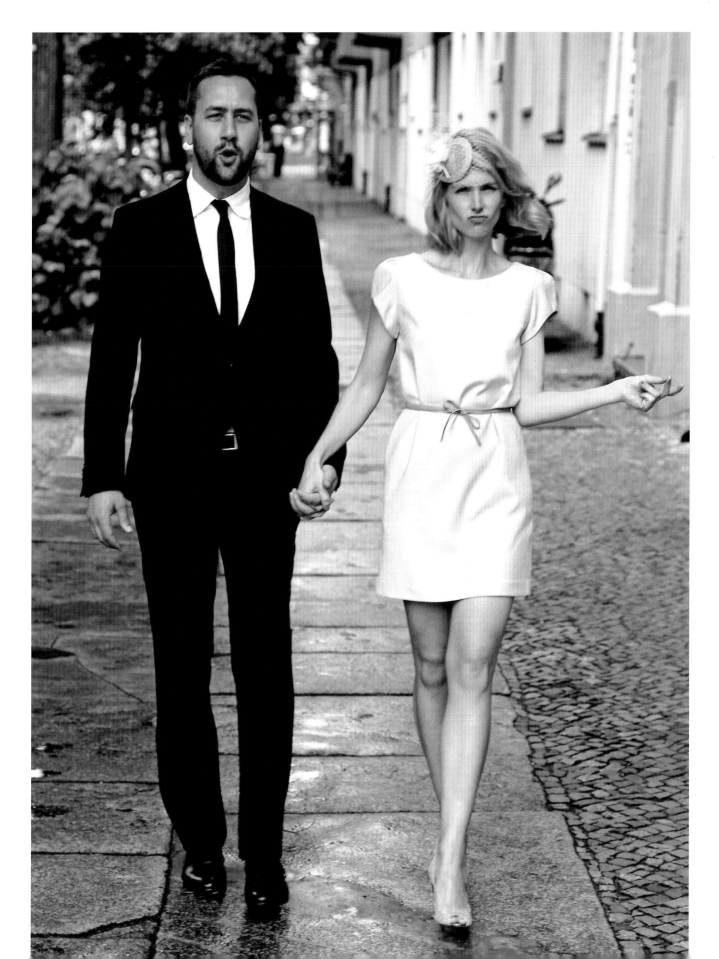

HOW TO GET MARRIED: OUR THOUGHTS

All bridal couples have their own
very personal ideas about what their
perfect day should be like.
Allow yourself to be inspired. . .

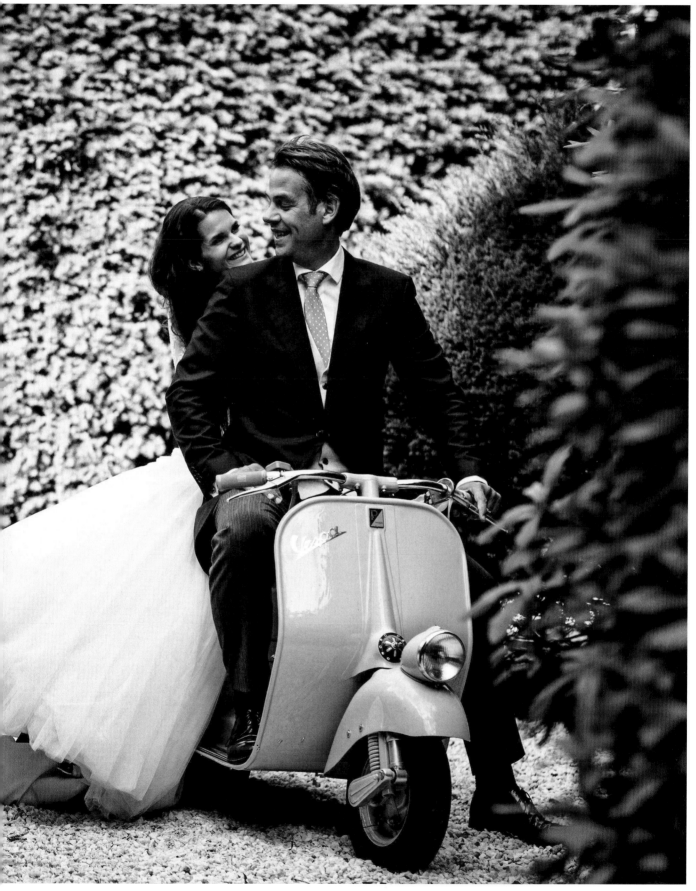

What is our budget; what do we want and what can we afford? Be careful! No matter how meticulous you are in your planning, there will always be additional costs here and there. Be sure to include these in your calculations so that there are no sad faces on the day because you have to do without the dessert or stand barefoot before the altar.

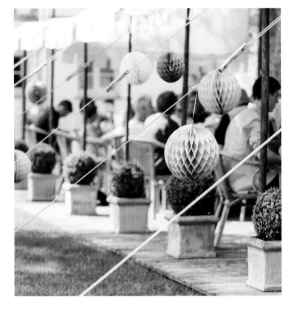

CHAMPAGNE OR DECORATIONS:
Think about what your budget
will have to cover

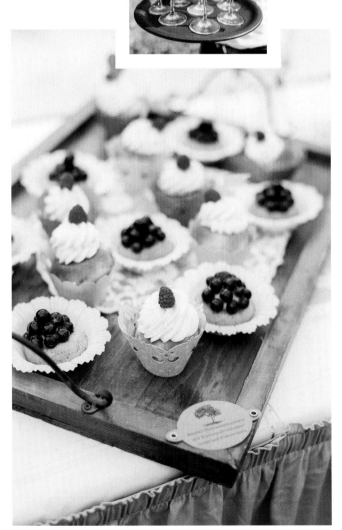

When and where do you want to get married? Things to consider in this regard: A beach on the Côte d'Azur works best in summer, snowy mountain landscapes are better in winter. At this stage, you should also give some general consideration to the guests, their arrival and departure, and the local surroundings. (More on this on page 26).

How would you like to get married? In a church, registry office, or some place completely different? How important is this aspect? Or how important are any potential traditions to your family?

Who do you want to help with the planning and how much freedom do you want to give these people? Surprises on the wedding day are a good thing, as long as the bride and groom are happy about them. However, not every bride wants to see a photo presentation of her husband's former girlfriends, and some mothers-in-law think old party photos of their new daughter-in-law are inappropriate.

Once you have decided on these points together, you should have a good basis for starting the detailed planning. A positive indicator of whether you are on the right track is and will always be your joyful anticipation of the big day. Imagine how you will celebrate with friends and family on this day. Does the thought bring a smile to your face? Very good, then you may proceed. . .

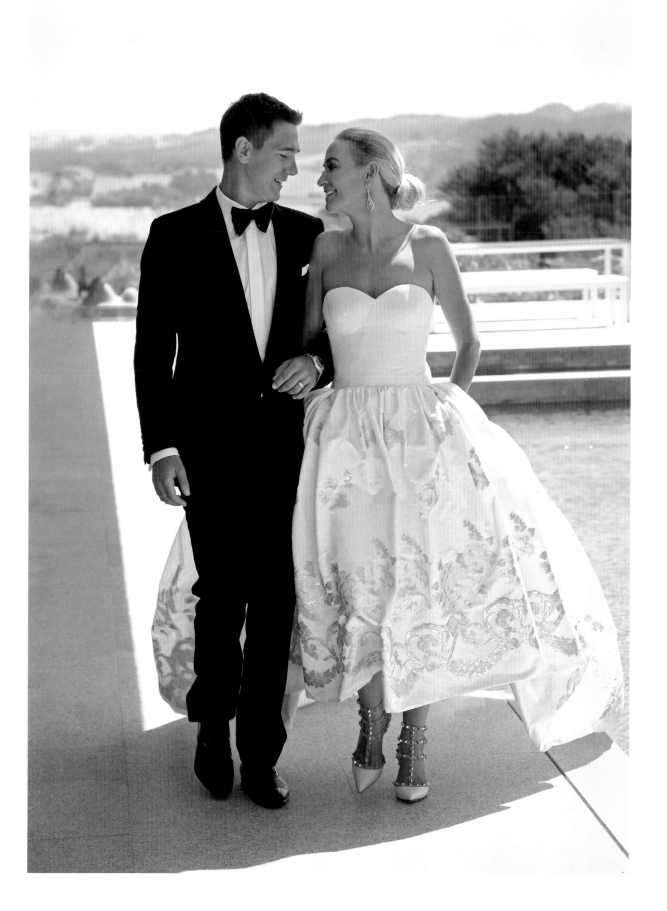

WHAT IS MOST IMPORTANT TO US FOR OUR WEDDING?

Decide together and then inform your family, friends, and witnesses of these decisions. This makes all of the planning easier and is an important first step on the way to having the celebration you want:

A roaring celebration and party atmosphere into the early hours of the morning

Festivity and tradition

Food and drink

Having as many friends, family, and acquaintances there as possible

At home or abroad

The main thing is that it is simple and uncomplicated

Intimate and private

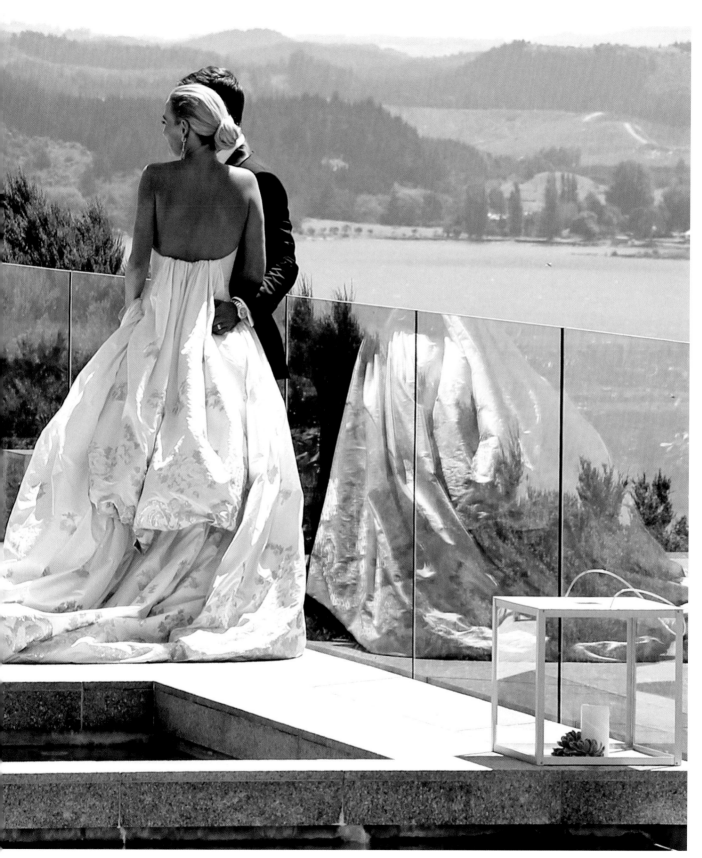

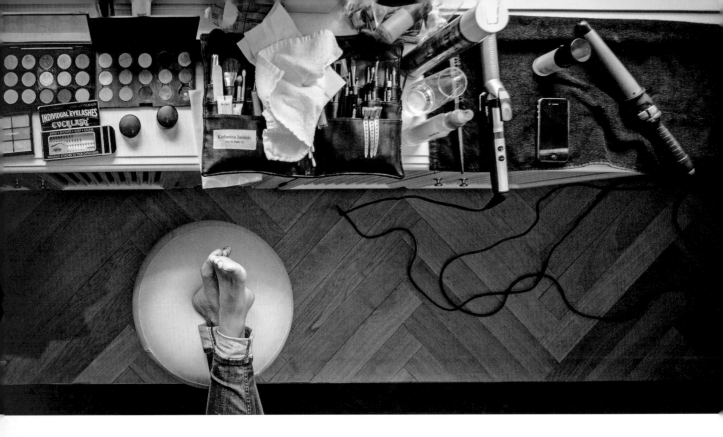

Better safe than sorry, or:
A good plan is half the work.

Once the general cornerstones have been set, there is no harm in looking at your wedding planning from the perspective of a project manager. All the work you invest in the beginning will be saved from the end and will make your life a lot easier. You don't have to start using Excel or PowerPoint right away, but a jointly prepared list of the various tasks and appointments should be doable for any couple; and it is also a great way to get in the mood for your joint celebration.

If you want to make things a bit easier for yourself, you can also ask us for help. Use the topics and chapters on the following pages as a rough guide. Let yourself be inspired by the images and ideas. Choose what you like best and what suits you. Each building block becomes a to-do on your list, to which you then add a due date and the person responsible. Et voilà! You have your own personal wedding plan. This is how easy it can be.

Don't be afraid to ask for help. As a general rule, mothers, prospective mothers-in-law, sisters, sisters-in-law, and friends are at least as excited about your celebration as you are and would love to help.

Warning: In order to avoid misunderstandings, be as clear as possible from the beginning about what you want and especially about what you don't want. Helpers are always glad to hear praise and words of gratitude. These are easier to express if there is real joy behind them.

A BRIDE AND GROOM, THAT'S OBVIOUS, BUT WHO ELSE DO YOU NEED?

To avoid standing alone at the alter on your big day and to make things a bit easier in the run-up regarding the distribution of tasks, here is a brief overview of the titles you can assign to family and friends and of what you can expect in return:

Mother and mother-in-law:
While they can't be chosen freely, they can be used freely as your wild card helpers according to their talents and abilities.

Father and father-in-law:
Also predetermined, they can walk the bride down the aisle, make speeches, and tip all of the helpers generously at the celebration.

Siblings and family:
Depending on their number, talents, and willingness, they can be drafted for all important and simple services. They are, after all, your close relatives. From background music to ushers, anything goes here.

Witnesses:
Anyone you trust is suitable. In addition to signing the register at the registry office or during the ceremony, the classic tasks include organizing the bachelor/bachelorette party and providing continuous support right up until the sun rises the day after the wedding. You should be able to unburden yourself of everything that is worrying you, from the fishtail skirt that is too tight and the shoes that are far too high, to a sobbing mother-in-law who doesn't want to let go of her child's hand.

The ring bearer:
Sweet nieces, cheeky godchildren, cute pets; anyone who can carry the rings up the aisle can take on this task. Here, you are allowed to base your decision on how photogenic they are.

Flower children:
Any children from your circle of friends and acquaintances who are old enough are suitable. A smart trick that is sure to work is to include one older child who can guide the smaller ones if something goes wrong. Another useful trick is to put candies under the flower petals to motivate the children to complete their very important task.

Professional support:
If you want to make things really easy for yourself, then hire a wedding planner to help. Nowadays, they are available everywhere and to suit any budget. From minor tasks to a complete carefree package, every kind of support is possible. But wedding planners should also be provided with detailed and precise information. Too much pink and too many frilly pillows, tiny snacks instead of the barbecue station you wanted, an ice sculpture instead of a chocolate fountain—all well-meant but maybe not right for you. So never hand over complete control of everything.

THOUGHT OF EVERYTHING?
There's no such thing as too much preparation

FAMILY

*From your mother-in-law
to your niece:*
There is a perfect task
for everyone.

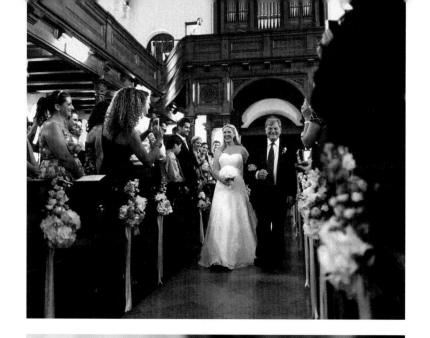

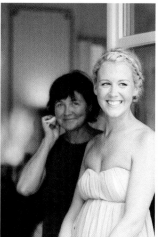

1

3

1 MOTHERS & GRANDMOTHERS:
A wedding connects
generations
2 NIECES & NEPHEWS:
Children make your
celebration come alive

**3 FOUR-LEGGED FRIENDS
ALLOWED:** You decide who
is part of your family

4 SISTERS & COUSINS:
Can practice for their own
celebrations on your big day

4

2

22

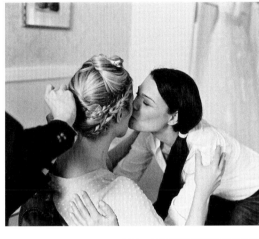

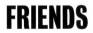

FRIENDS

Bridesmaids and best men:
Your best friends are
just as excited on the big day
as you are.

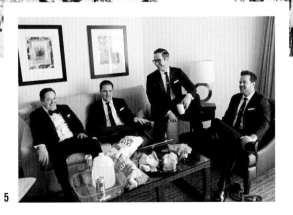

1 THE WITNESS: Will support you throughout the day **2 SMALL GIFTS:** Often give great joy **3 BEST FRIENDS:** Support you when you laugh and cry. . . **4** . . . and make sure you have enough to eat and drink **5 THE BOYS' CLUB:** The bridegroom should have plenty of support too

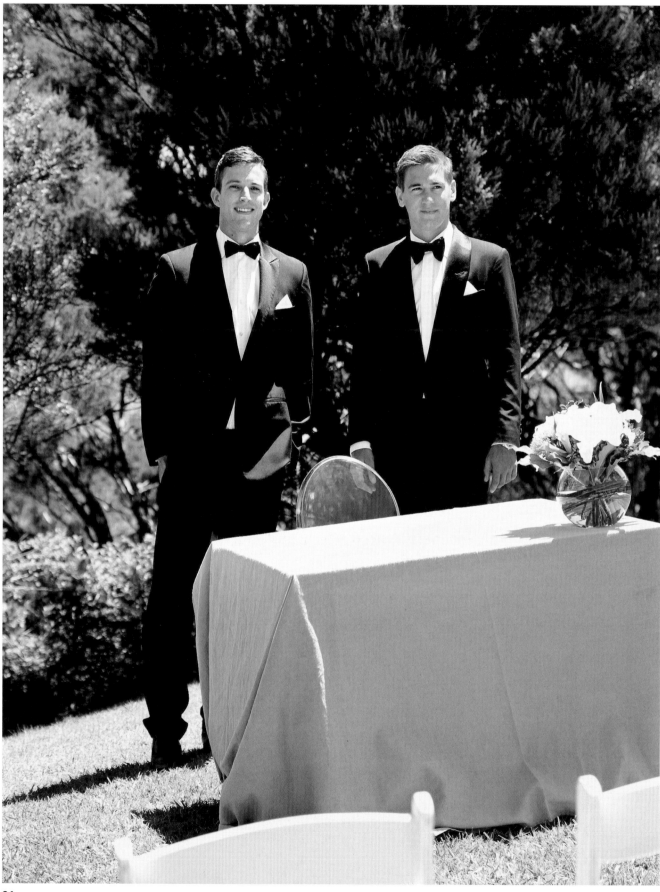

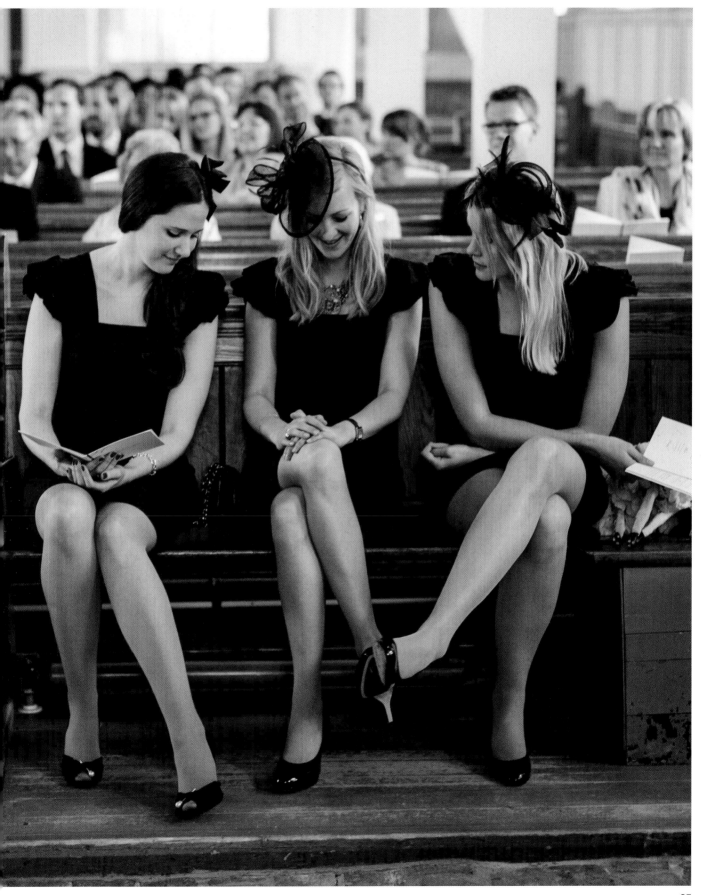

When, where, how, and with whom do we want to celebrate our wedding?

Be careful, this is where it gets serious. Here are the four most important questions regarding your wedding; the cornerstones upon which you build your celebration, so to speak. The crux of the matter is that everything depends on everything else: The location depends on the time and availability, the space depends on the number of guests, accommodation, and accessibility, and so on and so forth. . .

Everything according to your own style. Many couples already have a favorite location because they feel particularly connected to a certain place for personal reasons or have simply fallen in love with a location. Others prefer a very special date (for example, a child's birthday or another day with special meaning, favorite numbers etc.) For others, it is important that the location can hold over 400 guests or can be festive with only

THE GUEST LIST

*You will need as detailed a guest list as possible,
at latest by the time you have decided on your witnesses
and want to send your save-the-date cards.
Here, it really is worth resorting to Excel. The more
detailed you make the list, the better it is for everyone
who needs to refer to it in the future. Some suggestions
for creating your list in Excel:*

Create tabs or categories: friends, family, colleagues,
sports club, and whatever else you might think of

Write down their names, addresses, e-mail addresses,
and, if possible, phone numbers

Mark couples, families, and children

Insert columns for acceptances and declinations and,
in the best-case scenario, for catering requirements too
(children, vegetarians, vegans, and people with allergies)

ten people. No matter what you decide
for yourselves what is most significant
regarding each of your priorities. On the
following pages, you will find inspiration
and suggestions for a variety of locations
where you can have a wonderful
wedding, whether the wedding party is
small or large. Here are a few things you
might like to consider:

PREPARATIONS

Is the location within your budget?
The most beautiful castle is only half as fun if there is only bread
and water for the wedding dinner.

Does the date suit the location?
The Caribbean in the rainy season certainly is cheaper,
but will your guests thank you for it?

Is the date and location feasible for everyone you wouldn't like to be without on your big day?
Sometimes, a faraway wedding or a celebration during
the school holidays is desirable for tactical reasons,
but please remember the appointments and mobility
of your nearest and dearest, ideally even before
sending the save-the-date cards (see page 32).

Who should come?
Make a detailed list of the people you want to invite and expect
(almost) all of them to come. Include newly added boyfriends or
girlfriends in your calculations, or think about how you want to
handle this situation. Friends who have recently fallen in love
may be insulted if they can't show off their new conquest.

Organize your guests' postal addresses at an early stage.
The euphoria of finishing the invitations or taking the save-the-
date cards to the post office shouldn't be dampened by a lack of
information.

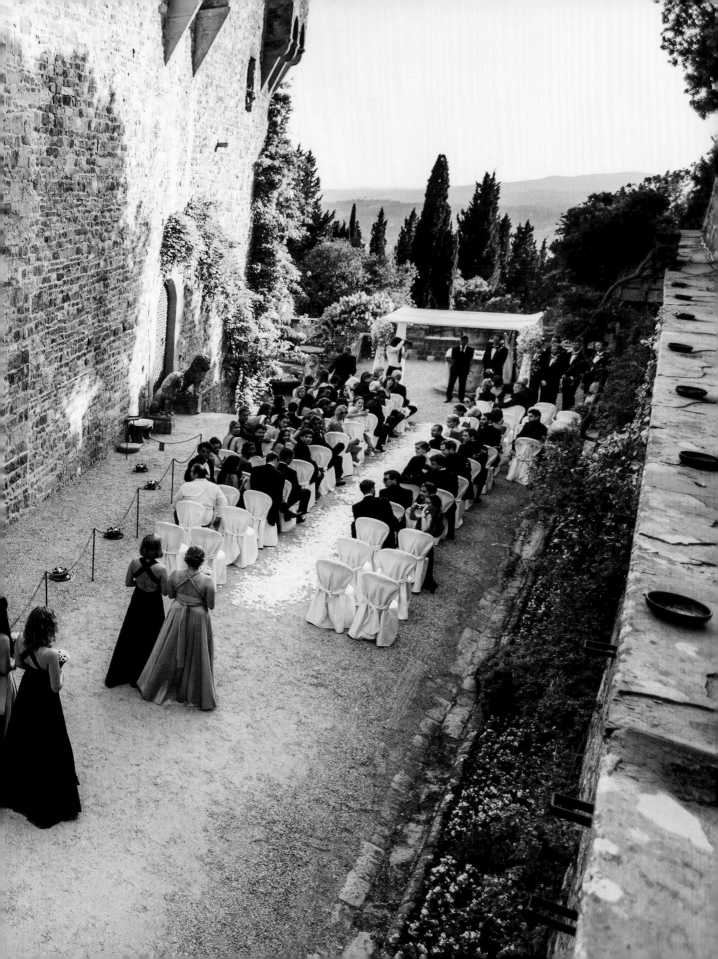

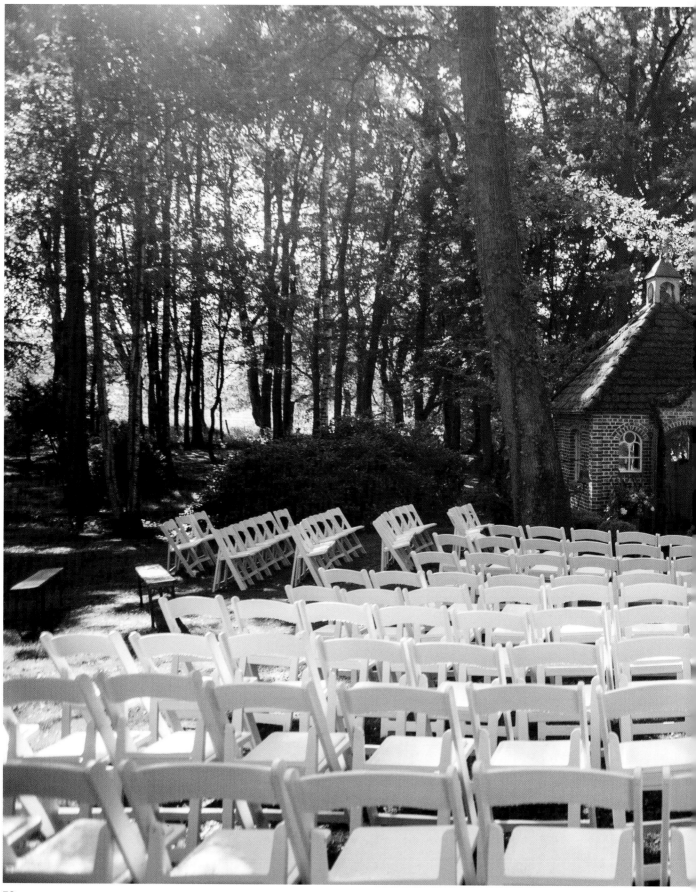

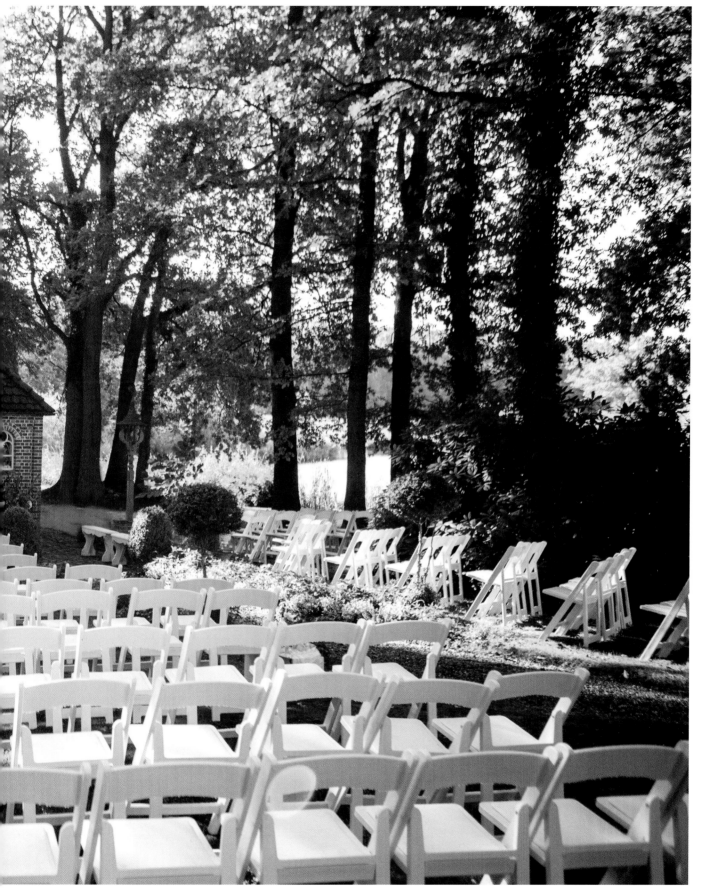

We Invite You To. . .

Congratulations, the most difficult part of the planning is behind you and you have decided when, where, how, and with whom you want to celebrate your very special day. Time to let the lucky people know.

Save the Party, Save-the-Date

You have already gone to a lot of trouble with your guest list during the run-up and have carefully chosen with whom you would like to celebrate. The best solution to making planning easy for your guests is the so-called save-the-date card. As soon as you have set the date and your address list is ready, you should send this information in advance. The date of the wedding is often sent with the engagement announcement, as this saves time and postage and provides twice as much occasion for celebration.

A good option that is often used nowadays that will also save you money is a digital solution, such as e-mail or electronic invitation. Today, this option is perfectly acceptable. You don't always have to send an expensive photo card. But the save-the-date card provides guests with the initial information about your celebration, while at the same time spreading a little happiness and giving them something to look forward to. Many service providers on the Internet offer a variety of inexpensive or even free options. If you want to get creative, you can, for instance, add your own style by making cards or envelopes using photos, quotes, pictograms, scrolls, or patterns.

The classic option and a real visual treat is, of course, a card or letter sent by mail. In an age of e-mails and social media, this is more emotionally charged and makes people happy. It's something enduring, not something you can delete by accident. A little tip: Have a stamp made with your sender address. A handwritten font can also make a beautiful stamp; the corresponding ink pads are available in every color of the rainbow and you will save yourself a lot of time writing the return address on the back of your envelopes. Don't under any circumstances leave out the return address, otherwise you won't receive returned letters and will have no idea whose letters have been delivered or not. Here, too, you can either grab scissors, glue, and pen yourself or engage a professional. If you would like it to be absolutely perfect, order the save-the-date cards together with the invitations, thank-you cards, and all of the wedding stationery, such as place cards, name cards, etc. Having everything matching looks impressive and creates a very harmonious overall statement.

The save-the-date card only needs to state the location, the exact dates, and you as the sender. Warning: If you are getting married in a faraway place, it is particularly important to inform your guests as soon as possible, so that they don't run into logistical difficulties getting to the wedding.

ON A PERSONAL NOTE
If you have a theme for your wedding, let your guests know what it is on the invitation

Die Hochzeit

SARAH
— UND —
SEBASTIAN

25. OKT. 2014
14:00 Uhr
MÜNSTER OBERMARCHTAL
Empfang und Feier
auf der schönen Maisenburg

MENÜ

Vorspeise
ANTIPASTIGEMÜSE MIT BÜFFELMOZZARELLA
CARPACCIO VOM ANGUSRINDERFILET
MIT JUNGEN PFLÜCKSALATEN UND PARMESANSPÄNEN
KAROTTEN-INGWER-SUPPE

Hauptspeise
RINDERFILET VOM BŒUF DE HOHENLOHE
MIT KRÄUTERKRUSTE
KARTOFFELGRATIN

Dessert vom Buffet
CRÈME BRÛLÉE
SORBET
MOUSSE AU CHOCOLAT NOIR
HOCHZEITSTORTE

Zeremonienmeister
CHRISTOPHER GIEHL
CHRISTOPHER.GIEHL@GMX.DE

SARAH UND SEBASTIAN
07472 9641537

R.S.V.P.

BITTE BIS 1. AUGUST 2014

ANREISE
Münster Obermarchtal - Klosteranlage 2/1
89611 Obermarchtal

Hofgut Maisenburg - Maisenburg 1
72534 Hayingen

Eingabe fürs Navigationsgerät: „Maisenburgweg"
dann den Pfeilschildern zum Hofgut folgen

**BLEIBE
UND FRÜHSTÜCK**
Ab 24:00 Uhr fährt ein Shuttle
zu Unterkünften in der Nähe.

ZUM BEISPIEL:
Flair-Hotel Hirsch - 72534 Hayingen-Indelhausen
Gasthof Pension Adler - 72534 Hayingen-Anhausen
Ferienpark Lauterdörfle (ab zwei Übernachtungen) - 72534 Hayingen

Frühstück am Sonntag, 26. Oktober 2014, 10:00 Uhr auf der Maisenburg

· Diakon ·
GODEHARD KÖNIG

· Musik ·
„GAURA"
FRANZISKA ZEGOWITZ & BORIS MAUCH

· Trauzeugen ·
ROMY LÖFFLER
NIKKI LOUISE CAMERON
REINHARD DREWS
DOMINIC JÄGER

· Blumenmädchen ·
MAREIKE DREWS
ELLA KOCH
MARA RUHNAU
FINJA RUHNAU
PATRICIA ZELLER

25. OKTOBER 2014
MÜNSTER OBERMARCHTAL
SARAH
— UND —
SEBASTIAN

Einzug der Braut – „Songbird" Fleetwood Mac
Begrüßung
Gebet
Lied: Gotteslob 458 (1.-4.) „Herr, gib uns Mut zum Hören"
Evangelium: Lukas 19, 1-10 „Jesus im Haus des Zöllners Zachäus"
Predigt
„Colorblind" Counting Crows
Trauung
Trausegen
Fürbitten
Vaterunser
Friedensgruß
Schlussgebet
Lied: Gotteslob 775 (1. 5. 6) „Von guten Mächten"
Segen
Auszug – „All I Want Is You" Barry Louis Polisar

RSVP

Whether you design them yourself or order them from a professional, your save-the-date notes and invitations are the first news your guests receive. *Remember—first impressions are important.*

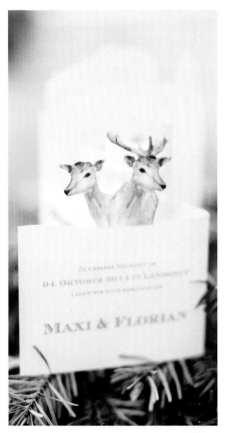

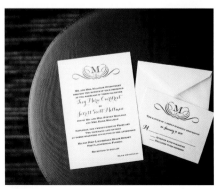

Whatever your invitation may look like or however much it contains, it is worth making a special effort to announce your wedding. Compared to all of the unwanted mail you receive, the arrival of a beautiful envelope, with a specially chosen stamp, and a handwritten address will charm the recipient and bring a smile of joyful anticipation to everyone's face. This is special correspondence that you wouldn't dream of tearing open on the stairs, but rather open them carefully with a letter opener. Add a personal touch to your invitation with flower petals, confetti, and other soft-colored surprises that flutter out of the envelope. All this shows your guests how much you are looking forward to them accepting your invitation. The invitation should include all of the important information for the guests: In addition to the date, time, and location, you should include directions, travel information, the dress code or theme, accommodation suggestions for out-of-town guests (ideally for every price range and category), and general information. You can put all of these details on different cards. We particularly recommend doing so if you are unable to invite all of your guests to all of the wedding events.

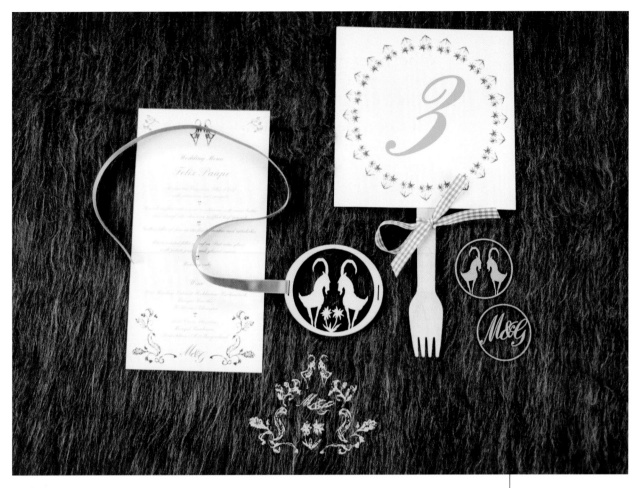

INVITATION & MORE:
The design of the invitation can be reproduced for all of the decorative elements

CREATIVE IMPACT:
There is lots of room for variation within the design

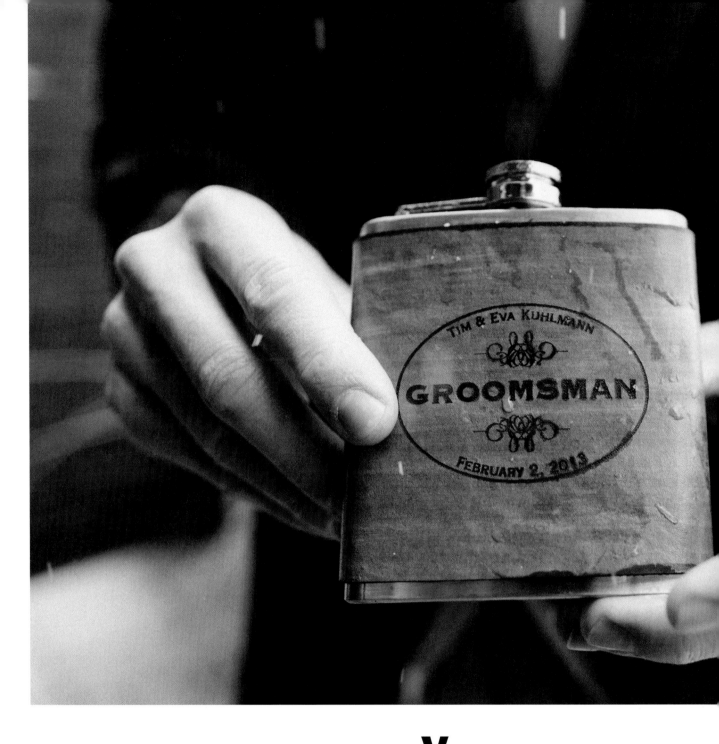

What about gifts?
"Your attendance is our greatest gift but for anyone who insists on bringing one. . . no appliances please. . ."

You have invited your guests to this great celebration and they would like to give you a gift. Maybe something practical, symbolic, and classic that contributes to your new life. But what do you want? What do you need? What do you need help with? Whether it's an item from your wedding registry, a donation to a favorite charity, a financial

WEDDING PRESENTS

If you need some ideas, here are a few classics:

<u>For house and home:</u>
Gorgeous bed linens, beautiful bath towels, bathrobes,
table linens, chargers, beautiful wine glasses,
all kinds of old silver, china, or perhaps a pair of
candlesticks. Plants are also appropriate.

<u>A windfall:</u>
Financial contributions to your honeymoon or a dream
you need help with. Perhaps you yearn for a tree house,
a new deck, or a chest of drawers from the antique store.
A small windfall is a fantastic idea even for wishes that
are yet to be discovered.

contribution to help with the cost of a honeymoon. Let your guests know what makes you happy. Ideally, it should be noted on the invitation. It will save your guests from having to wander aimlessly around stores, guessing, and hoping that what they choose suits your taste.

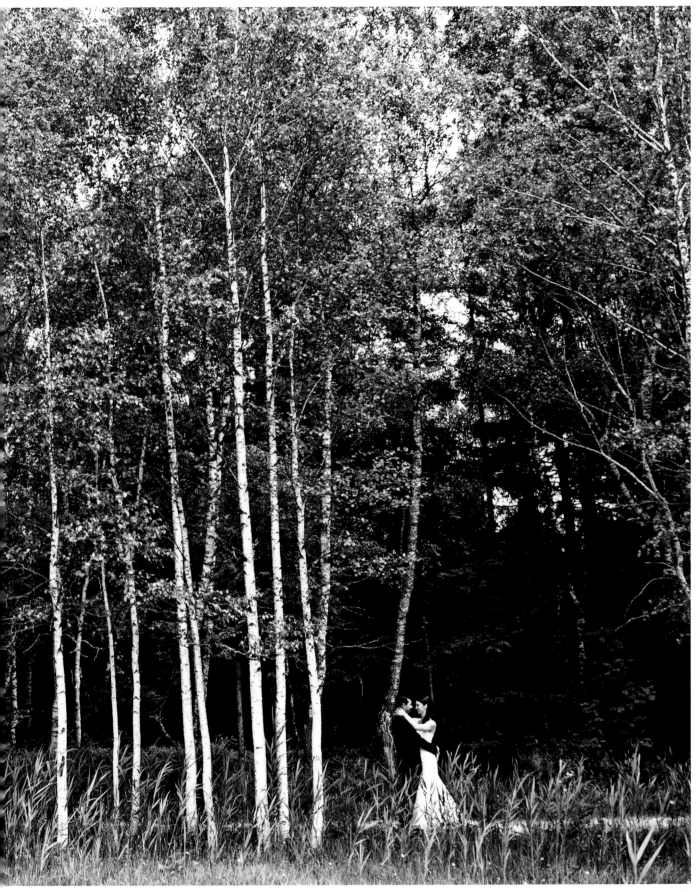

INDOORS OR OUTDOORS?

The season will determine the location. An open-air wedding only works in sunny weather.

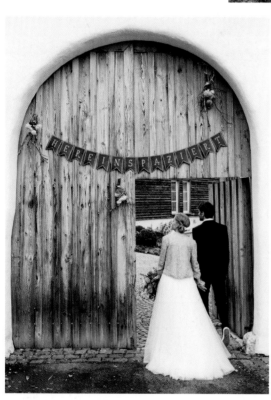

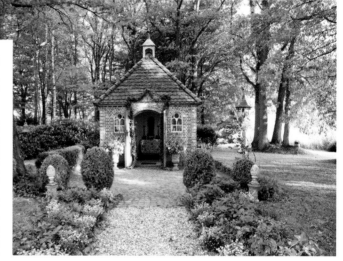

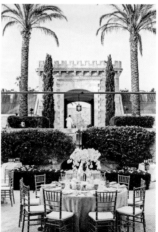

1 What is hiding behind the gates?

2 Vineyards and country estates are always great locations...

3 ...as are enchanted gardens...

4 ...and Mediterranean palaces make quite an impact, as well

40

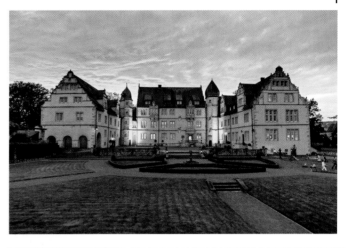

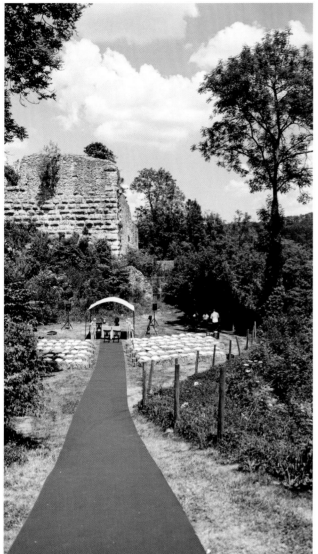

NORTH OR SOUTH?

You should carefully consider how exotic you want your destination to be. *What can you expect from your guests with regards to travel time?*

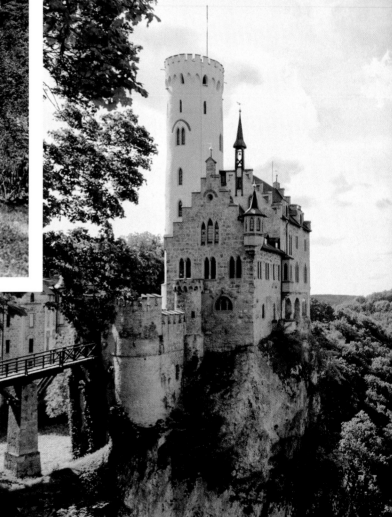

1 Marrying under the open sky is particularly nice... **2** ...especially in combination with a glamorous red carpet and straw seats **3** Rocky mountain castles also have their charm

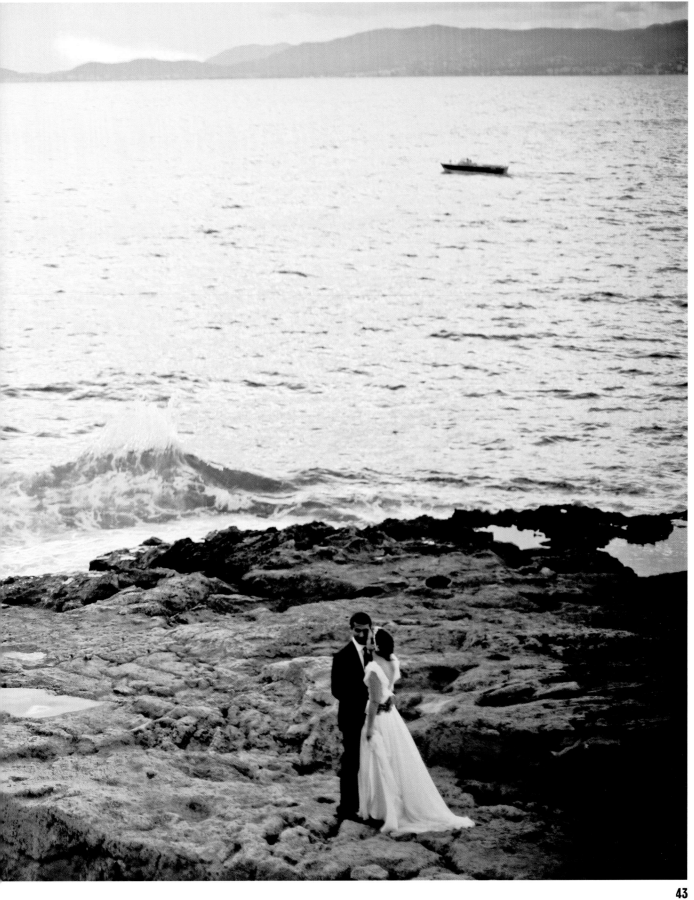

Make the Most
of Your Location

You have already decided where you want to get married, the date has been booked, and further preparations can begin. Now it's about making the most of the location. Many wedding locations are professionally run. You can relax and allow yourself to be guided through the process by in-house experts. Often there are pictures of other weddings, established contacts, and suggestions for catering, music, etc. In order to avoid unpleasant surprises regarding the cost, please don't forget to ask for a full price list. If you are planning this yourself, you should take a closer look at the location and the surrounding area and make sure that both are suitable for the occasion. Keep the following points in mind:

Celebrating in the city comes with certain risks, for example, insufficient parking spaces or access made more difficult due to another big event. It's advisable to plan for all eventualities at an early stage and to provide guests with solutions.

If you prefer a country wedding and find a suitable location in a rural setting, you will have the advantage of being able to spend a few days with your guests. It's like inviting your nearest and dearest on a short vacation. On this vacation, your guests belong to you and you to them. However, to ensure that no one feels constrained, you should establish the necessary infrastructure to provide both you and your family and friends with the flexibility needed to enjoy your wedding vacation to its fullest extent. For example, you should make sure you offer your guests different types of accommodation. You should also provide for the necessary logistics, such as a shuttle service or taxis, so that these few days in the countryside are not limiting or restrictive to anyone. With careful planning, you can also re-create the freedoms offered by the city.

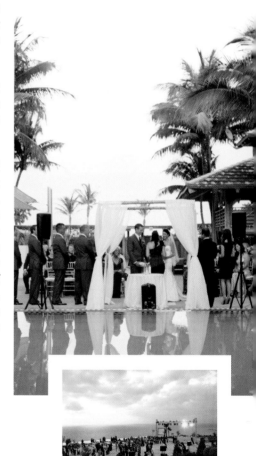

ALL-INCLUSIVE:
Be creative and find out how to make the most of your location.

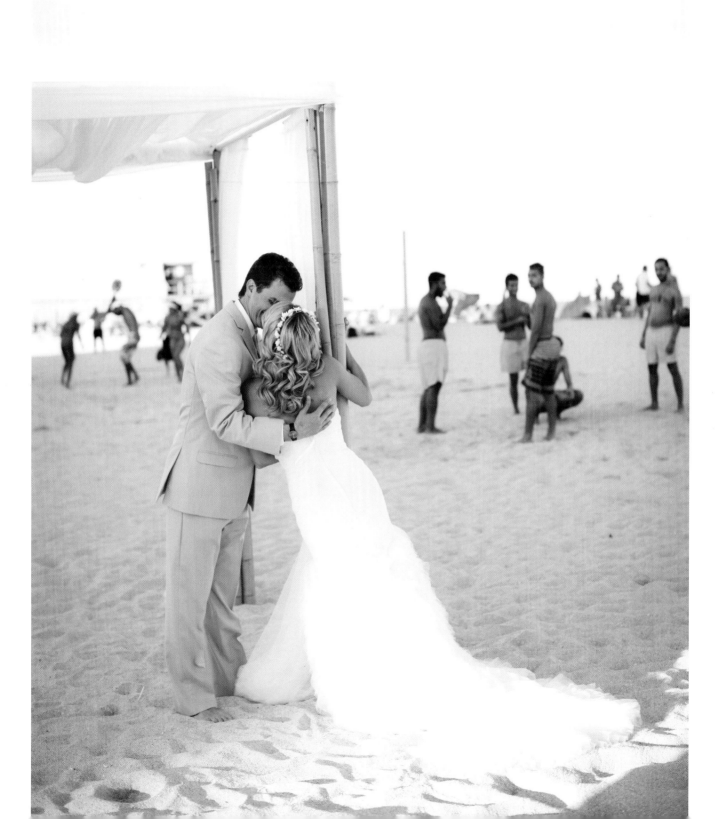

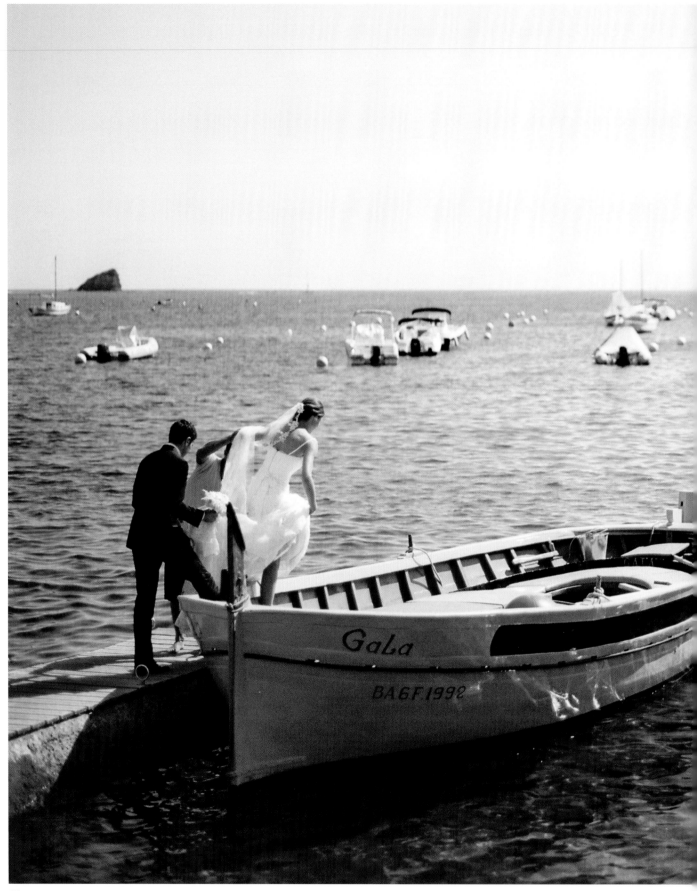

DECORATIONS AND SETTINGS

Whether you decorate the tables
yourself or leave it to the organizers:
*it's best to agree on what is
to be done and how beforehand.*

TABLE SETTINGS:

It's up to you to decide how to
decorate, but the décor shouldn't
distract from what's important.

On the following pages you will find various suggestions for decorating and embellishing the space you've chosen for your wedding. Usually the setting is a determining factor but whether it is rustic or more opulent, keep the big picture in mind and make choices that reflect your personal preferences.

It all starts with the empty space. Be careful not to choose a space that is too big. Nothing guarantees a more depressing atmosphere than looking from the dance floor into a big, half-empty hall. A square or round space is recommended rather than a long rectangular one. The bar should be right next to the dance floor. Guests tapping their feet to the music with a drink in their hand contribute to making the occasion more enjoyable. At least one third of the guests will be standing at the bar and they are usually the most sociable of the party. If the bar is far away from the dance floor, it will never really fill up and the atmosphere will suffer as a result. You really want to draw your more sociable guests to the heart of the action. For larger weddings, we recommend that you set up two bars to avoid long lines. An elongated bar may not be particularly pleasing to the eye, but it keeps things moving. Having a bar menu and enough service staff is essential, as it saves time for both guests and staff. The bar menus can be framed and displayed for everyone to see.

THEMED PARTY:

A theme always lends itself to harmonious decoration

OUTDOOR PARTY:

A lounge provides a perfect place to retreat to

THOUSANDS OF OPTIONS
AND DECORATING IDEAS

In order to ensure that the pictures and
memories are as joyous as possible,
we advise you not to overdo it.
The classics last longest.

CANDLELIGHT:
creates a
romantic
and classy
atmosphere

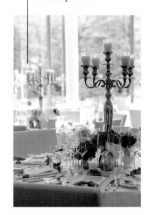

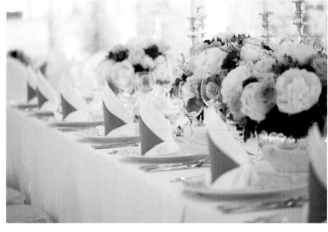

San Diego

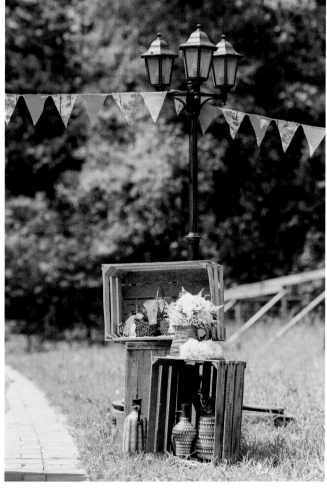

TONE ON TONE:
Color-coordinated
decor works
harmoniously

**NATURAL
EMBELLISHMENTS:**
If the location
is already beautiful,
it can be left alone

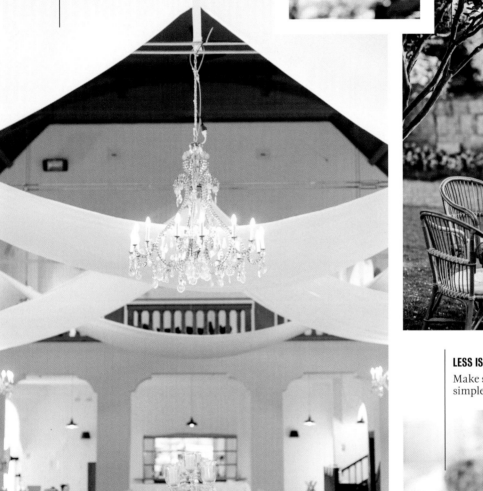

LESS IS MORE:
Make sure to integrate
simple elements as well

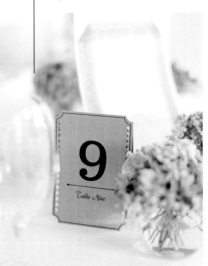

9

Table Nine

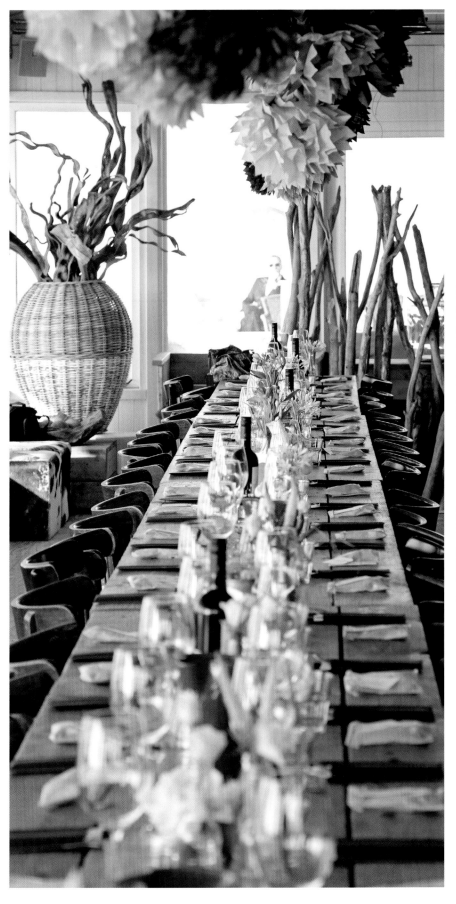

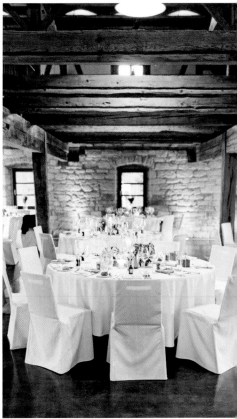

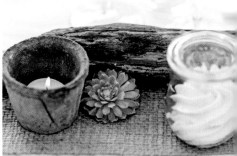

RUSTIC FLAIR:

If your location is a little more rustic or modest, adapt the decorations accordingly. Chandeliers or chair covers aren't appropriate everywhere.

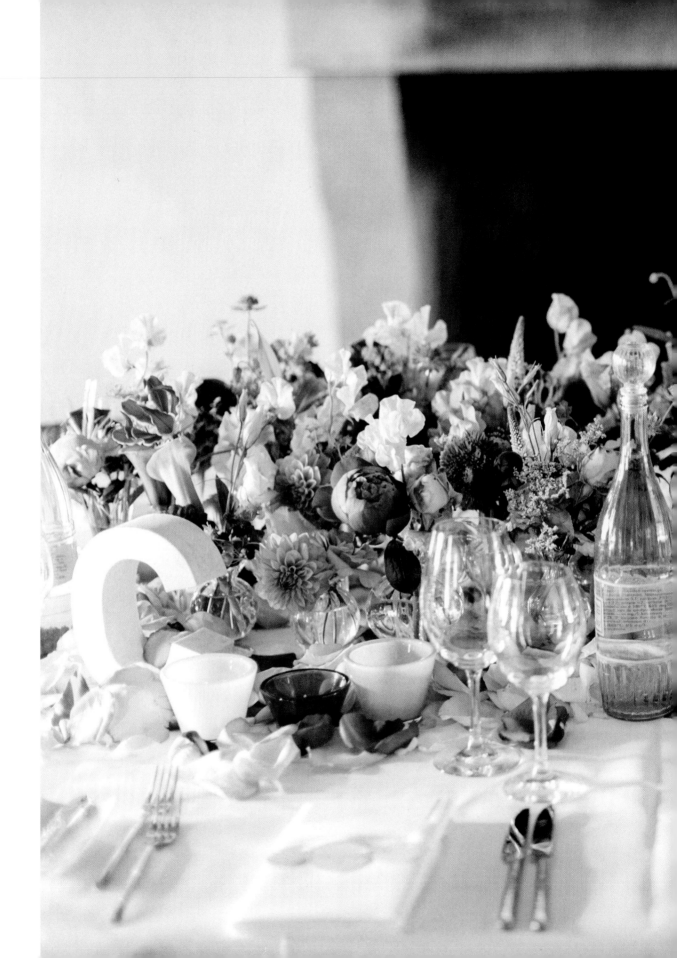

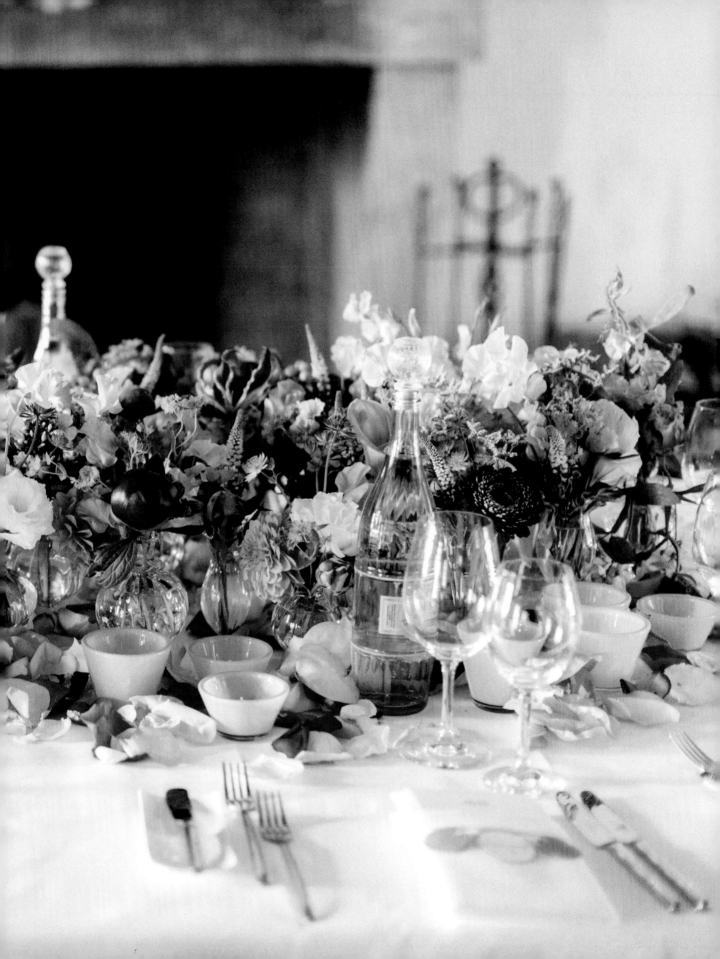

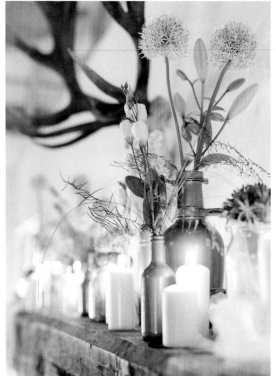

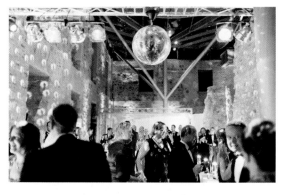

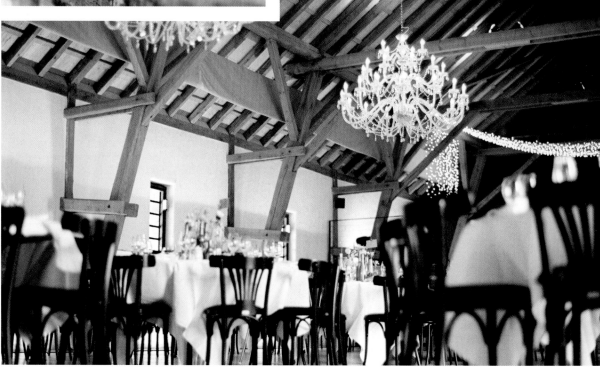

THE LIGHTING

Lighting is also important. Subconsciously, we respond to the light around us and it influences our mood. The space should be bathed in warm, pleasant light

if possible. During the meal, the room shouldn't be so dark that no one can see what they are eating. As soon as the dancing begins, the lights switch to disco mode—a little bit darker and softer using tasteful colors. Even more mature guests will be reminded of their youth and join in the dancing.

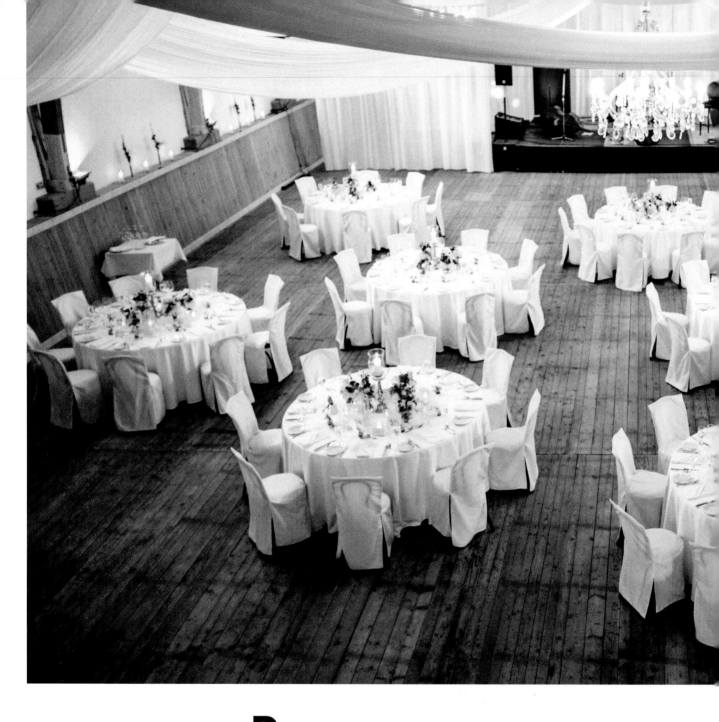

At the table,
joy should take pride
of place.

Round tables, rectangular tables, and U-shaped tables are very popular. Individual tables encourage good conversation. Keep in mind that round tables have a small diameter. This means that the person sitting opposite is not miles away, and it's possible to talk over the centerpiece without shouting at each other. The disadvantage is that this arrangement requires a lot of space. Long rectangular tables save space and each guest can converse with his neighbor on either side and with the person sitting opposite. Further conversations, however, can be difficult. Arranging the tables in a U-shape is popular for wedding parties because the bride and groom (sitting in the middle) can be seen by almost all of the guests without turning around. Choose

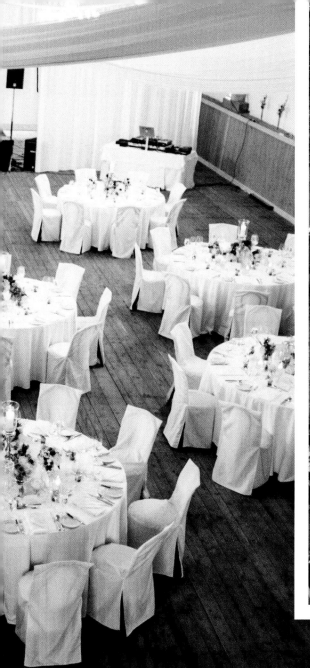

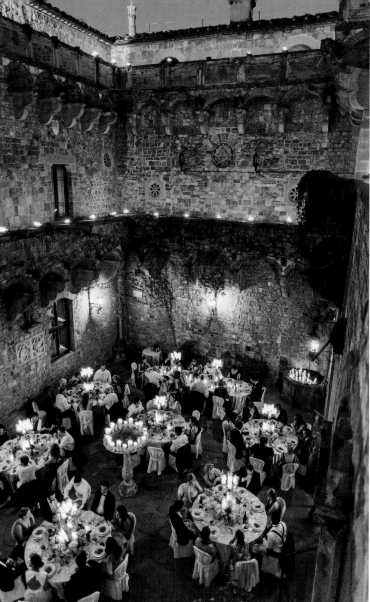

a bridal table for the bride and groom and those closest to them. Usually, the bridal party only sits on one side of the table facing their guests. Good alternatives to round and rectangular tables are oval tables, which combine the benefits of both. If the wedding dinner and dancing are to take place in the same room, individual tables often have to be cleared away after the meal to provide enough space. It's advisable to place the bridal table on the dance floor so that it's the only table that has to be removed quickly and easily after the meal. Food is usually served at the bridal table first. The bride and groom also stand up first at the end of the meal and go from table to table presenting themselves to their guests. It creates a nice atmosphere and allows them to speak to their guests in person again. During this period, the bridal table can be quickly removed without having to ask the guests to leave their seats. The festivities transition elegantly from dinner to dancing.

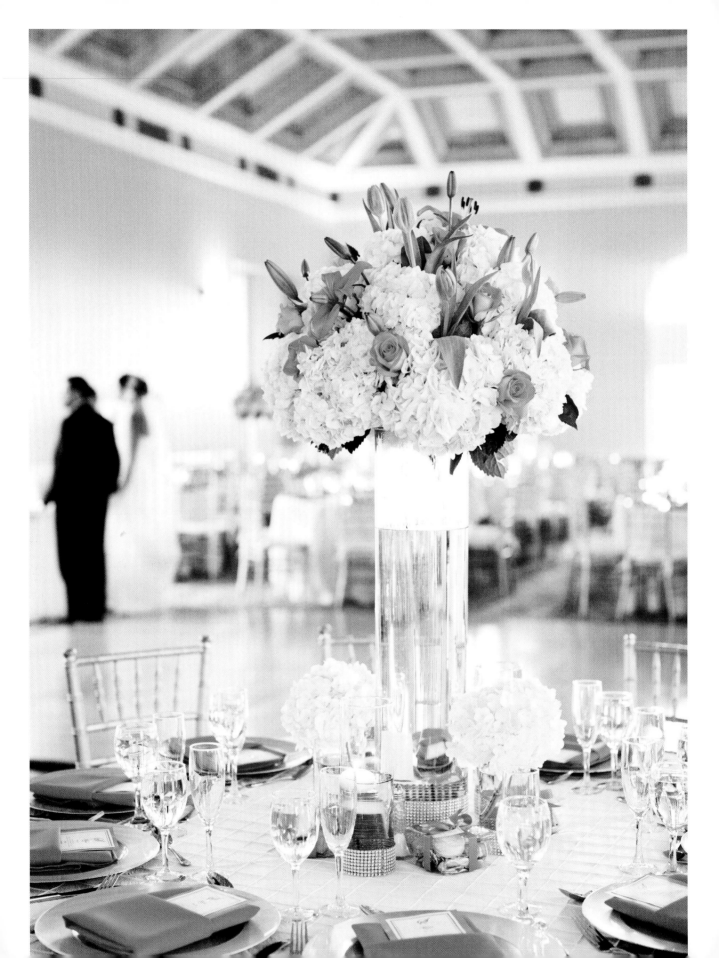

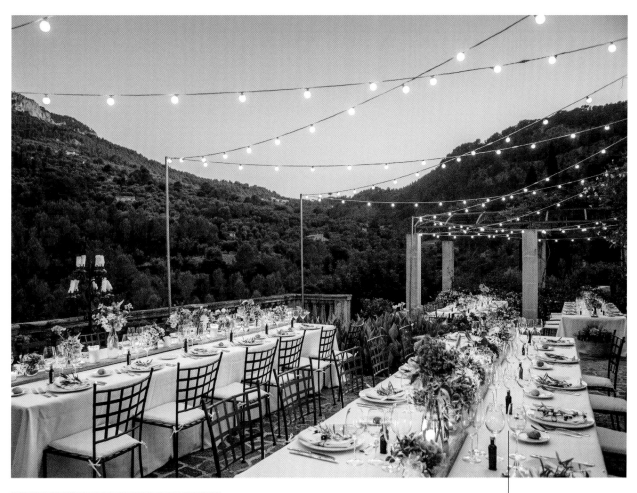

UNDER THE STARS:

Think about atmospheric lighting for outdoor celebrations

FRESH FLOWERS:

are great table decorations, but they are expensive

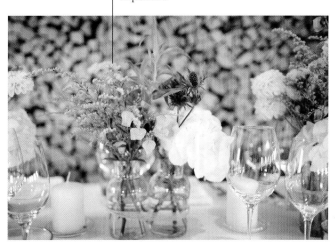

THE SEATING ARRANGEMENTS

Creating a seating arrangement
can be a lot of fun. You should ignore anyone
who warns you about this task.

Look carefully at the guest list. Approach it systematically. Putting people with related interests and of similar ages together always seems to make sense. Everyone has heard of the famous "singles table" and its reputation. Isn't it more enjoyable for singles to have single neighbors? And without partners who are constantly checking to see if everything is alright. This allows guests to chat freely and informally. It's also a "yes" to the singles table. There is no correct seating arrangement. If you are unsure, take the easiest and most logical approach: Place couples who are already friends or who you believe would get on well together next to each other, as well as single guests if there are enough of them. Be careful not to place singles into the furthest corner of the room. Make sure they are seated close to the bar and dance floor. There are often a few motivated dancers among them who will contribute to lifting the mood. If there is a good atmosphere, everyone benefits and, if not, at least nobody has to sit sad and alone near the restrooms. Apart from that, avoid placing older guests near drafty exits. Generally speaking, it's not worth worrying too much about the seating arrangements. Be brave and assume that the guests will be electrified by your big day, excited about dancing, and in an excellent mood. They have come to celebrate with you and are looking forward to being part of your wedding. Use your energy to look forward to your celebration. Ignore negativity, which always exists.

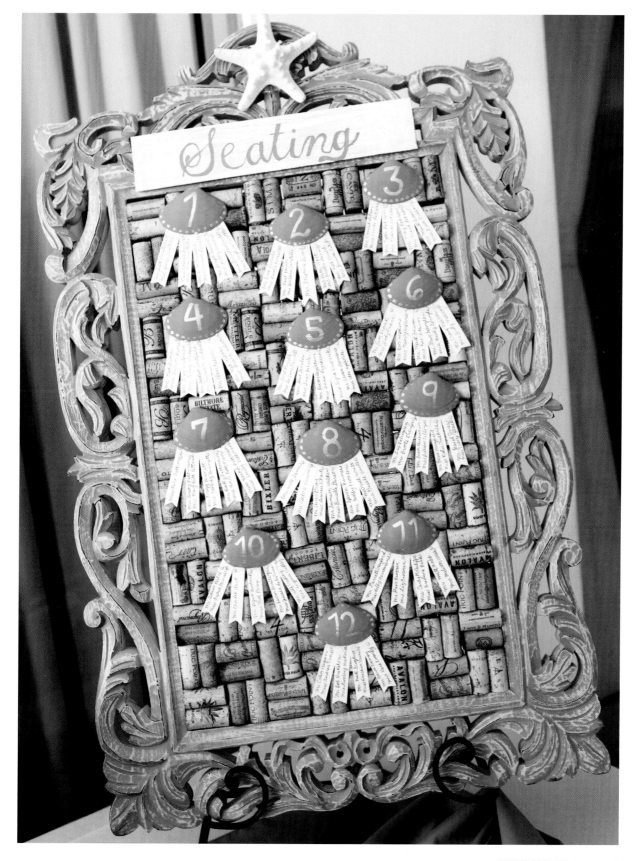

WHO IS GOING TO SIT WHERE?

Each guest should be able to find his or her place easily
and be happy with their neighbors at the table

Everything should go as well for your guests as for you on your wedding day. In order for your friends and family to share in your joy and happiness, and celebrate with you for as long as possible, it's important to provide enough food and drink during the event. You should keep this in mind when allocating funds. No one is going to be happy with expensive canapés if they are still hungry afterwards. Think the entire event through and be quite generous when considering where, when, and how food and drinks can be served. Here are the most popular options:

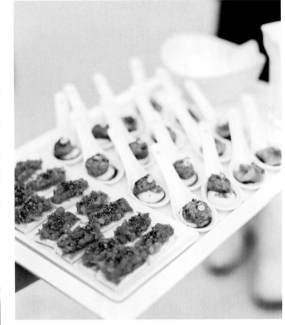

A LITTLE SNACK IN BETWEEN COURSES:
Your guests will be delighted with plenty of little snacks

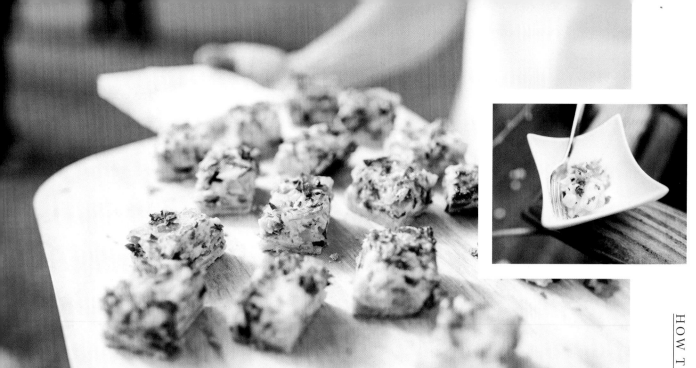

Canapés,
Flying Buffets,
and Snacks

In order to avoid your guests starving between the ceremony and dinner, offer small, tasty snacks at the reception. These can be served in the form of a self-service buffet or passed as hors d'oeuvres. Canapés should be appetizing, bite-sized finger food. Guests might be a little overwhelmed trying to manage a welcome cocktail in one hand and an amuse-bouche spoon in the other. All of the guests will enjoy one main station and/or several small stations where tasty treats are presented and easily accessible to everyone. Who hasn't been to a reception where the waiting staff have passed by again and again holding empty trays? A lower cost option is to serve traditional snacks that guests can help themselves to. Some locations allow you to bring your own food, but you should ask beforehand. Many couples also serve coffee and cake upon arrival. Whether you want to cut the cake early in the afternoon or save this classic dish for dessert after dinner is up to you.

After the Greeting, the Real Wedding Celebration Begins: *the Dinner*

Bridal couples are overwhelmed by choices. A set menu is quite festive and more appropriate for the occasion than a buffet, which offers greater choice. Planning the evening can be arranged more easily based on a set menu. Speeches can be made between the individual courses. The only downside to set menus is the higher cost and lack of choice. Opinions will differ here and you will never be able to please everyone, so the best thing to do is simply choose what you prefer as a couple.

A FEW TIPS FOR
THE DINNER

Don't serve starters that are too exotic;
the same applies for the main course.

Don't serve meat before fish.

The side dishes must match the main dish
in terms of quality.

Soups are complicated! If serving a soup,
then only go with a clear soup.

Try to serve food that is easy to eat, so that you
spare your guests any embarrassing scenes.

Seasonal vegetables make great side dishes
and seasonal fruits make for delicious desserts.

The main course should consist of
popular types of meat.

As a considerate host, you will already have asked
your guests on the invitation whether they are
vegetarians or have specific dietary requirements
or allergies.

As a rule of thumb, each course should
go with the next: Thai soup should not
be followed by Wiener schnitzel. When
choosing the food, you should try to suit
all tastes. Traditionally, a wedding menu
consists of the following four courses:

Starter
Appetizer
Main course, possibly two options:
Fish or meat and don't forget
the vegetarians!
Dessert
Don't forget the *coffee or espresso*
to finish off.

SOME TIPS FOR THE BUFFET

Serving tables shouldn't be too close
to the dinner tables.

Buffets should be set up to allow
for more than one entry point.

Find out in advance about how
the serving dishes are arranged and in
what manner they will be plenished.

For the best buffet, serving stations will
alternate with dishes prepared on the spot;
a barbecue or pasta corner are always popular
and will keep guests in a good mood.

Make sure you choose main courses
that go well with side dishes.

*Whether a set menu or buffet, a dinner dance
is a nice way to create a relaxed atmosphere.
The guests can stretch their legs between
courses with some charming dance steps.*

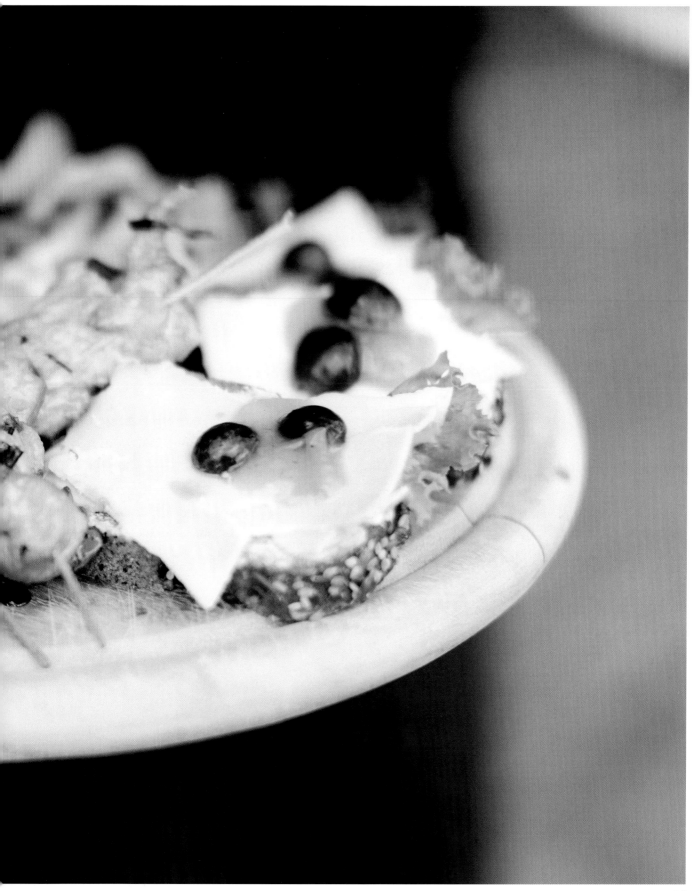

DESSERT AND CAKE

When it comes to desserts and sweets, there are two schools of thought; some people can and want to keep nibbling throughout the day, others not at all. *A buffet is a very elegant solution that will keep everyone happy.*

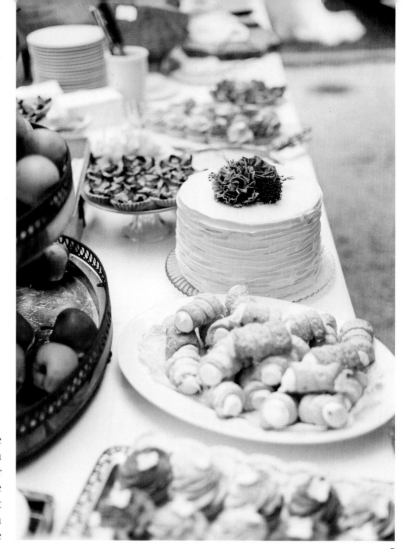

It is best to serve dessert on a buffet. Even if the dinner has been served, the last course, can offer a selection of small dishes that guests can choose for themselves. Sweets and cheese can be offered at the same time. Guests who prefer to skip dessert are not left in the awkward position of sitting through a whole course with nothing to eat. Traditionally, the wedding cake is cut after dinner for dessert. If you have special preferences for your cake, it is best to explain these to those responsible for ordering it. You should definitely sample your wedding cake before making your choice, especially if it's going to be served as dessert.

1 FLYING CAKE:
Portion-sized treats are easy to serve

2 SWEET TREATS:
Elaborate treats always show a little extra consideration and appreciation

3 OPULENT BUFFETS
Allow your guests to help themselves

1

3

2

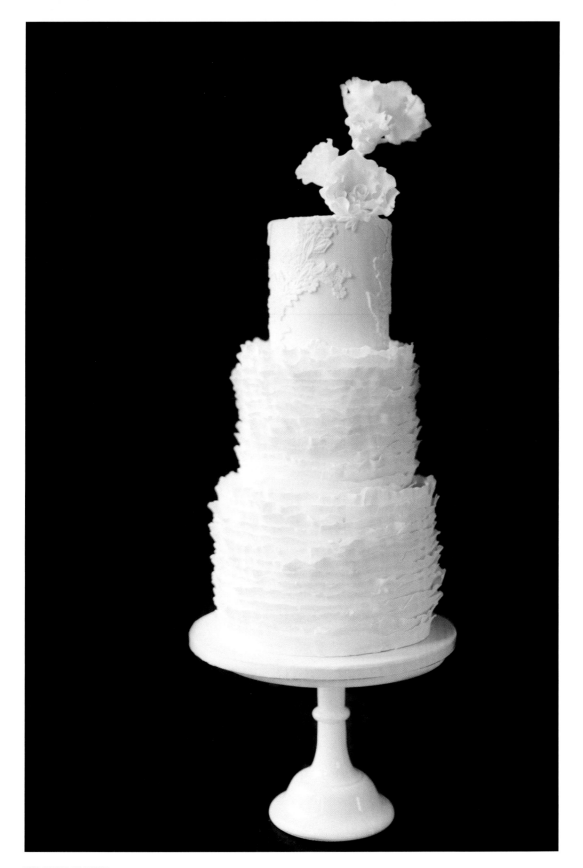

THE QUEEN OF CAKES:
is the wedding cake, and you should feel free to go overboard with the design

CAKE POPS:
Easy to eat while standing and holding a drink in the other hand

CANDY BARS
are particularly welcome later in the evening

Get creative with what you serve
ON SKEWERS

SWEET FRUIT
is always a good alternative to cake

Portions can be easily prepared
IN GLASSES

CUPCAKES
in different variations work well at the buffet

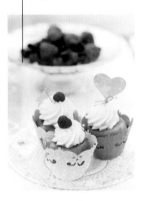

THEMED CAKES
should not only look good, but also taste great

THE STRAWBERRY CLASSIC
is popular with all wedding guests

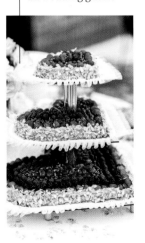

A STACKED WEDDING CAKE:
The presentation of the cake can create another moment of magic

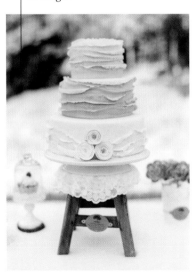

Who Isn't Familiar with
the Cravings of the Witching Hour?

Offering a late-night snack is a must during the celebrations. There are almost no limits what you can select, from simple cheese cubes with bread to the classic midnight soup; almost every guest will be pleased with a little fortification after the exertion of the last few hours. The important thing to remember is that small snacks should be easy to eat when standing and should not require silverware.

LET THE CORKS FLY— DRINKS

There is no celebration without the right drinks. From classic champagne to original drinks: What's important is that your choice goes with the food.

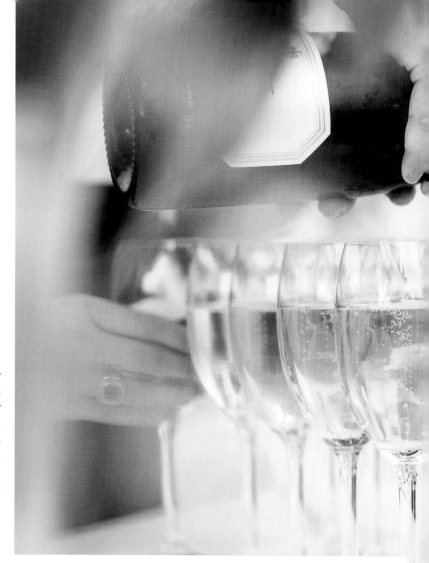

Alcoholic beverages are important on your special day. But don't forget to provide your guests with non-alcoholic drinks as well. On hot summer days, especially, there should always be enough water available, as well as juices and soft drinks if possible. Drinks are almost as important as the dinner. Don't forget the children, the elderly, and any pregnant guests. A creative non-alcoholic alternative for toasting is sure to make you popular.

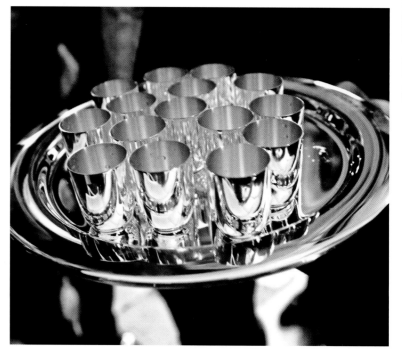

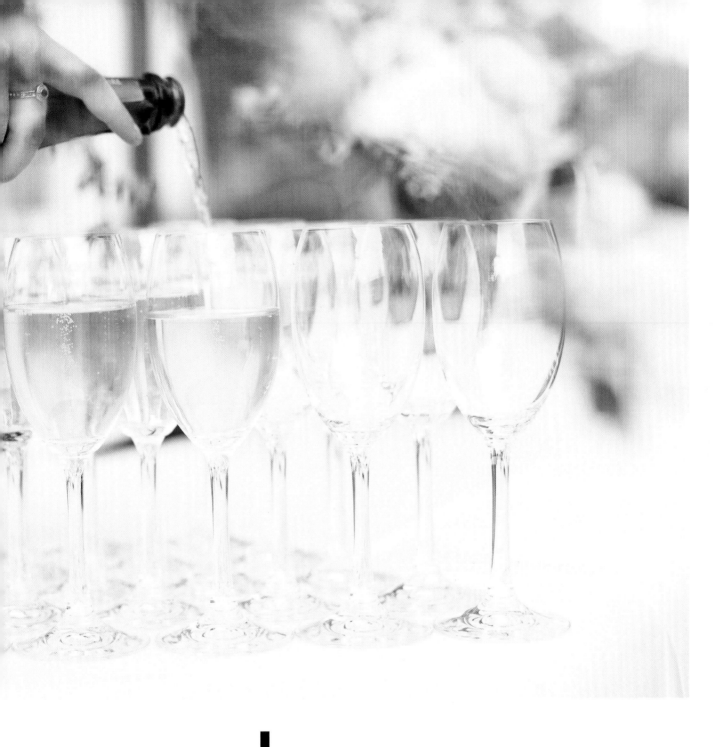

The Aperitif

If the wedding budget allows, champagne is the best choice at the reception. However, it doesn't always have to be the most well-known brand. Expert advice is worthwhile. Sparkling wine, crémant, or prosecco are inexpensive alternatives to champagne. Cocktails are also a popular alternative for the reception. Younger guests will be especially delighted with a trendy aperitif such as Aperol Spritz, port and tonic, a Hugo, or a Lillet. You can surprise your guests with your own tried-and-tested creations. The respective drinks can be beautifully decorated with seasonal fruit, vegetables, and spices, such as cucumber and mint.

The Wine Accompaniment to the Meal

When selecting the wine to accompany the meal, you should pay particular attention to neutrality. For example, white wine shouldn't be too intense, flowery, heavy, or acidic. The same applies for red wine, which should be very drinkable and easily digested, and preferably not fatigue-inducing. Depending on the menu, a good caterer or restaurant should be able to recommend a wine that can be sampled in advance. If you have decided on the food and are still unsure about the choice of wines, you could also go to a wine store for advice. Offering two different whites and reds depends on the budget; it is a good idea, though. The wines should also be listed on the menu on the tables.

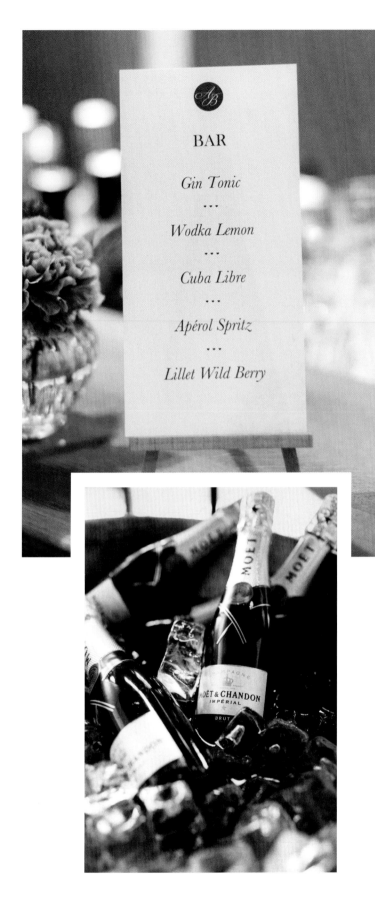

At the Bar

When planning the evening, the bridal couple should make sure that spirits are only served after the meal or main course so that guests aren't dancing on the tables before the starter is served. After dinner, the evening should reach its high point with dancing. To avoid every guest asking for obscure drinks at the bar, it's a good idea to have a drink menu on the bar and at the standing tables. After-dinner cocktails, such as a Moscow Mule or a Gin Basil Smash, are trendy and will definitely impress some of your guests and get them on the dance floor. At many weddings, guests are often glad to see that a wide range of cocktails are available in addition to beer and wine. When it comes to cocktails, it's important that mixers such as tonic water and Coca-Cola aren't poured from plastic bottles. The content doesn't taste very good or look attractive. Plastic bottles generally have no place at a wedding. If your budget is limited, ask the caterer, restaurant, or whoever else is responsible to transfer all drinks from plastic bottles into decanters.

At this point, there is nothing left to say but:
Cheers! Let's get this party started!

THE DRESS CODE

The most important thing is that you like the way you look. *Nothing is more enchanting than a bride who feels beautiful.*

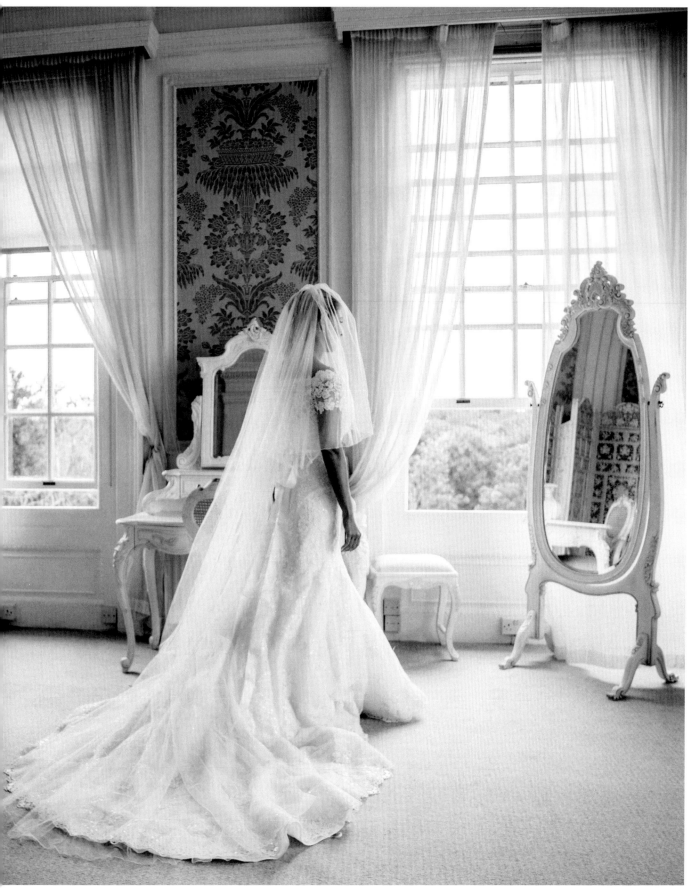

W hat am I going to wear?! This is a question most of us worry about, even if we are only invited to a wedding as a guest. When it comes to choosing your wedding dress, many women come close to having a nervous breakdown. You don't have to let this happen! Good advice is invaluable. On the following pages, you will find a brief overview of suitable bridal outfits to suit all body types, and we also help with dressing the bridegroom and the guests. Don't worry; nobody will have to stand naked before the altar.

APPROPRIATE FOR THE OCCASION:
The dress code of the day
should also suit the location

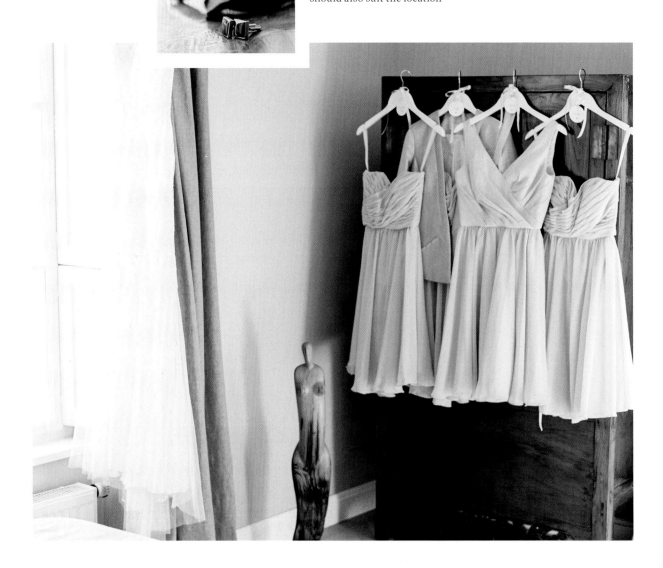

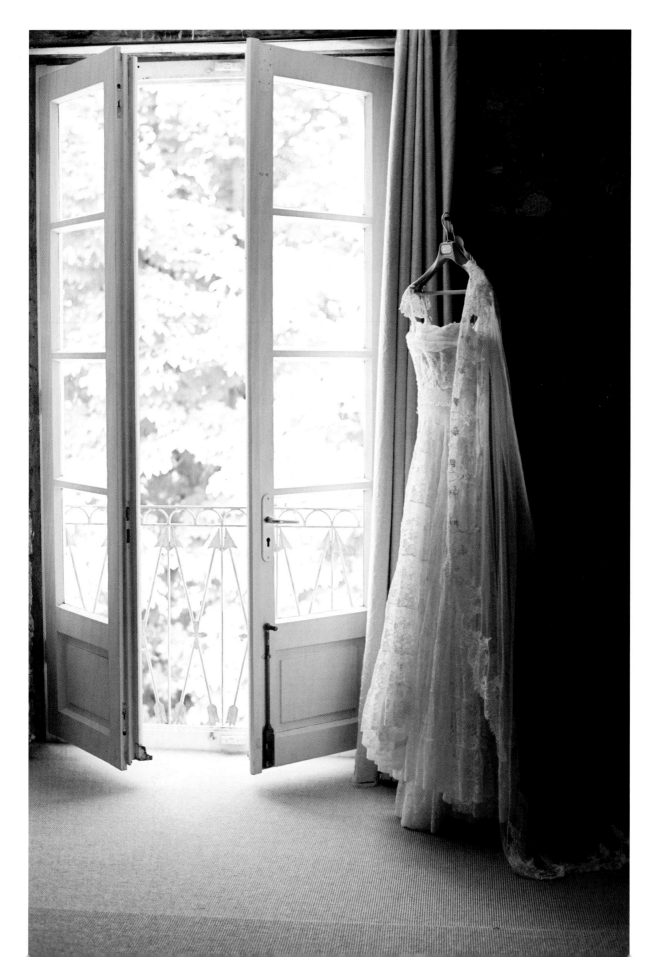

LACE, SILK, AND LOADS OF TULLE— THE WEDDING DRESS

For many brides, the dress is
the most important part of the whole wedding,
and that is absolutely fine. *Once in your life,*
you get to play the princess and dance
until the sun rises.

PRINCESS OR FAIRY?
Today, wedding dresses are available in
almost every fabric and form, and you
are sure to find your personal favorite

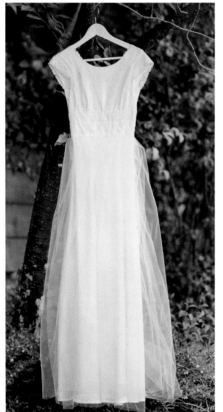

Hard to imagine, but white wasn't always white. In Central Europe, brides just wore their best dress on their wedding day. It was often either black or the respective local traditional costume. The color, however, wasn't important. It was only after the English Queen Victoria married Prince Albert of Saxe-Coburg and Gotha in 1840 in a white dress, that this color became fashionable for wedding dresses. The fact that the color "white" was considered to be a symbol of innocence and purity further contributed its appeal around the world. Beginning in the 1920s, white bridal gowns became increasingly popular. Despite this, white is far from being the color of choice in every country. In some cultures, white is a mourning color, and in China and India, red is traditionally worn because it is considered lucky.

In terms of fashion, wedding dresses have changed to fit the styles, trends, and cuts of the times. On international catwalks, a wedding gown is often the last and most important image in a fashion show and serves as the centerpiece of the collection and the designer's masterpiece. The range of options is endless, but this doesn't make the choice any easier. In the end, the right dress is out there for every woman's personality.

Whether structured, long-sleeved or bandeau, pixie-like or regal, ballerina dresses, trouser suits, or other two-piece ensembles, there is nothing that is not available or that you can't have. Whatever you like is allowed. The fabrics, too, are as varied as the silhouettes. From traditional, elegant lace to stiff taffeta and flowing silk, the endless diversity gives every bride the opportunity to select and combine everything she has ever wanted in one dress—and to have the dress she's dreamed of since she was a little girl.

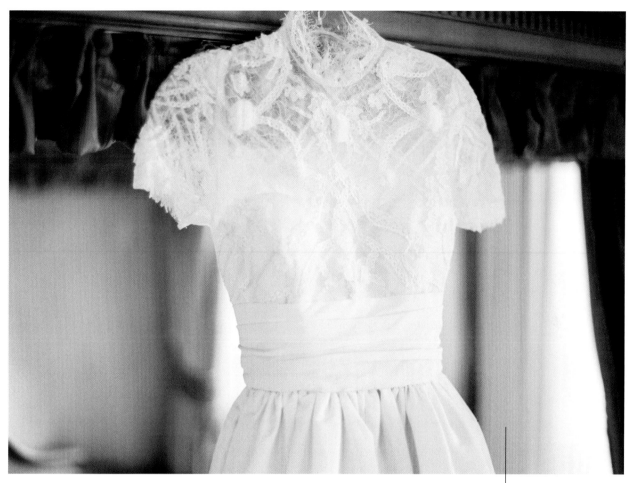

FINE LACE
is a timeless classic you can't go wrong with

HEMS AND TRAINS
embellish a dress visually, but they are not always easy to wear

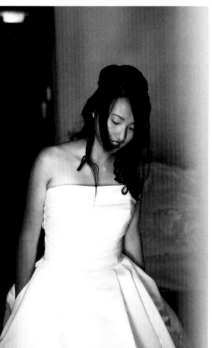

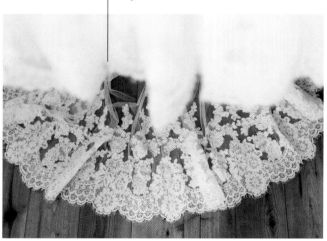

83

THIS IS HOW YOU ARE GUARANTEED TO FIND YOUR DREAM DRESS

Here is a brief guide to help you find your dream dress:

Browse through magazines and bridal publications,
get a general idea of what is available, and mark what you like best.
If it's something you enjoy, you can put together a collage and
choose your favorite options from it.

In the early stages, find out about the prices in advance and decide
what you want to spend on your dress. Don't forget the accessories.

If you like, get your friends and/or mother involved in making
this choice. The ladies are sure to be delighted.

Make appointments at the bridal boutiques well in advance.
It is often the case that you won't find the right dress
on the first visit and some companies have long delivery times,
or special alterations may be required.

Be open and try on at least one dress that isn't
on your list of favorites.

Don't be discouraged if you don't find your dream dress immediately.
Good things take time and it is worth continuing to look.

If you already have a very specific idea for your dress, it makes sense
to discuss this with a bridal dressmaker. You can get a unique,
bespoke piece made especially for you.

And most importantly: Enjoy every fitting! This is your day
and your special dress, and you are entitled to be a little princess again;
this is perfectly acceptable and you will remember it forever.

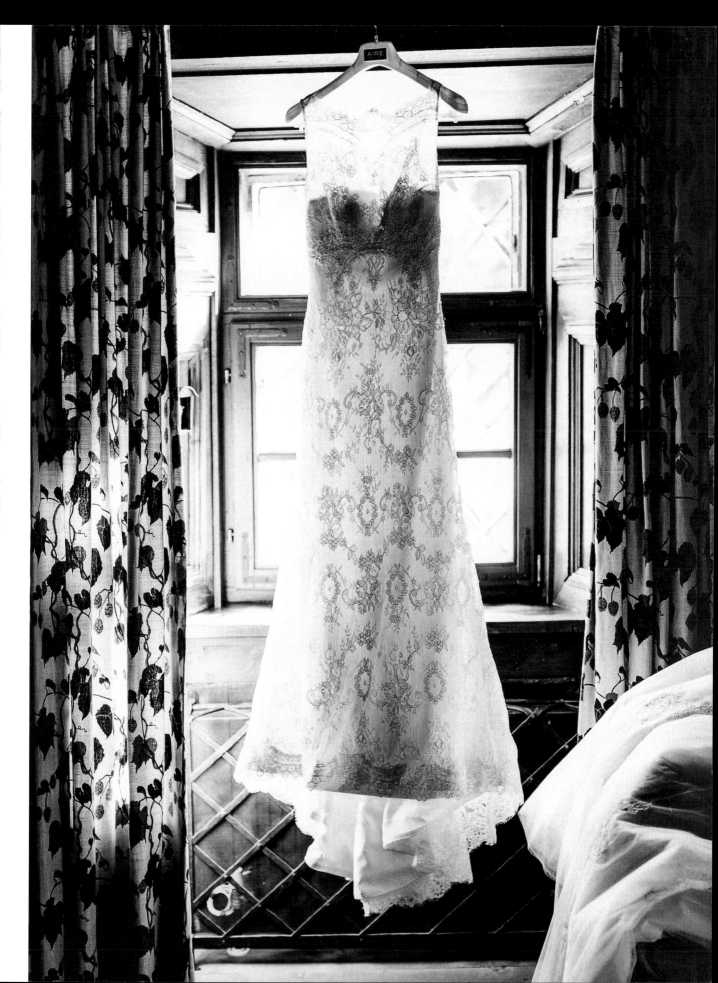

WHAT ABOUT THE WEATHER?

It depends on the season and the weather of course, but we recommend that you always have something to protect you against the cold and rain, just in case. It's cool in churches and you

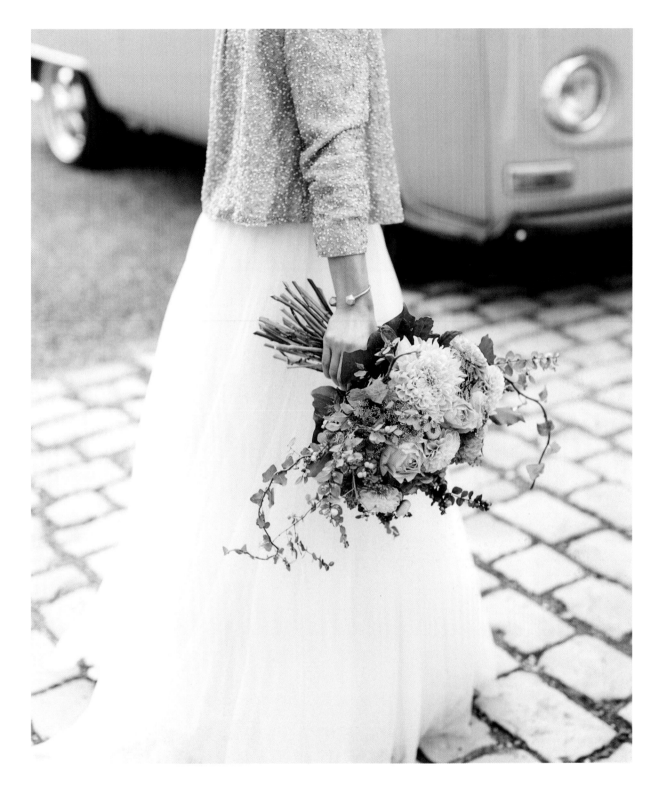

shouldn't be dressed too revealingly in any case. Bare shoulders aren't welcome. Cardigans or a large wrap to match the gown provide warmth and add a nice finishing touch to your wedding wardrobe. But remember to take the extra garment off every now and then, so that you can also be seen in your full glory—not just by the guests on your wedding day, but also for the photographs. Defying the cold a little is definitely worth it.

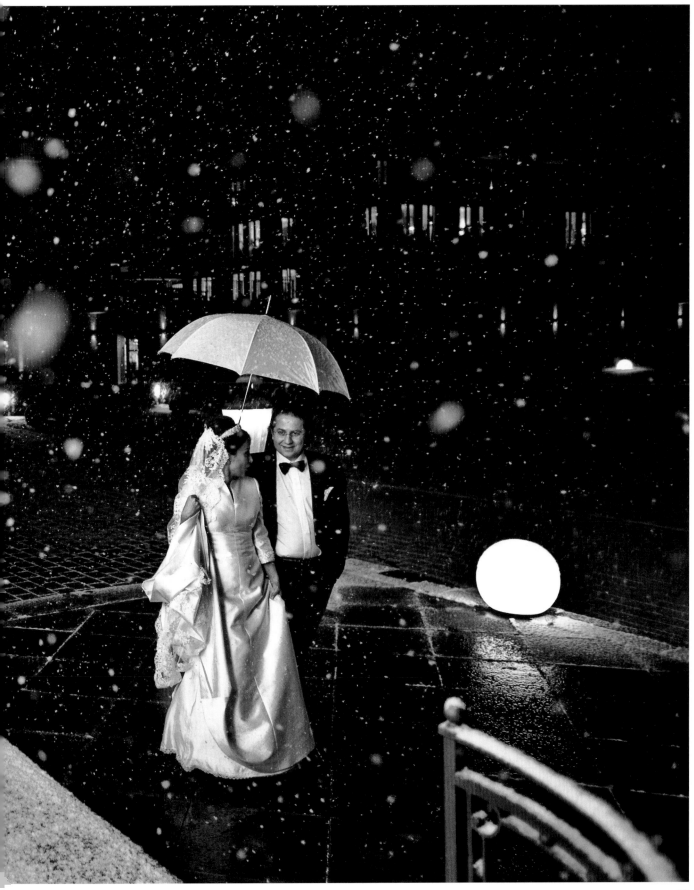

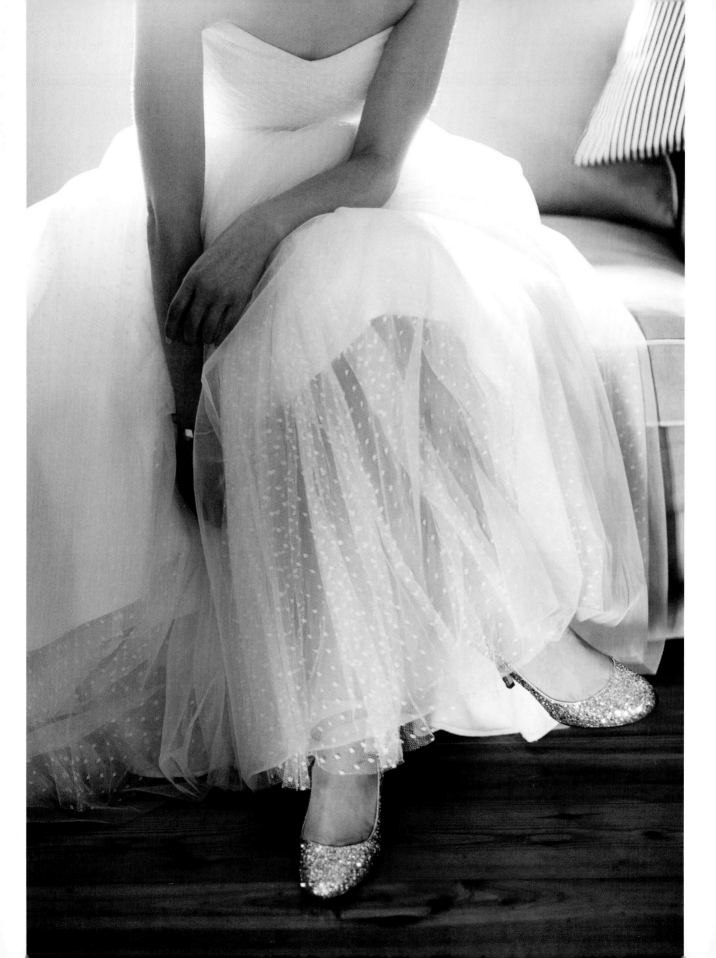

ANY DRESS CAN BE A WEDDING DRESS; ALL IT NEEDS IS A BRIDE.

*Whether you have always had a clear idea
or it is something you never gave a single thought to
until the day you got engaged, the good news is
that your dress is out there somewhere, whether
extravagant, mini, maxi, long, wide, short, with or without
pearls, stones, or embellishments. All styles, all possibilities,
all wishes can be sewn in a few stitches for your
big appearance. The most important thing is to find or have
a dress made that suits you, reflects your personality,
and makes you the absolute center of attention.*

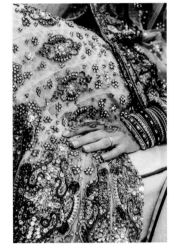

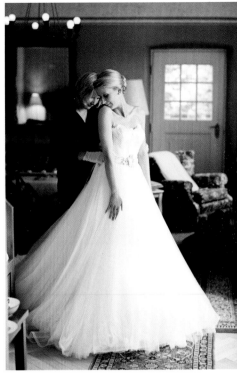

Narrow, slender bodies:
One-piece gowns and long, narrow dresses
or airy, lightweight pixie looks.

Classic hourglass figures:
The mermaid cut, which skims the body
and fishtails out from the knee, emphasizing
your silhouette. Waist-cinching dresses,
perfectly positioned cutouts, or transparencies.

"Apple-shaped figures" with a generous mid-section:
Emphasize your décolleté, for example, by choosing
an empire-line dress with a flowing skirt.

Broad shoulders or a voluptuous décolleté that gives the body a V-form:
Wide skirts or short dresses.

Pear-shaped figures, with narrow shoulders and shapely hips:
Dress shapes that define the décolleté
with a flared skirt.

For voluptuous ladies:
Two-piece outfits or gowns without frills or applications.
If you would like to appear slimmer, instead of white
choose off-white or champagne.

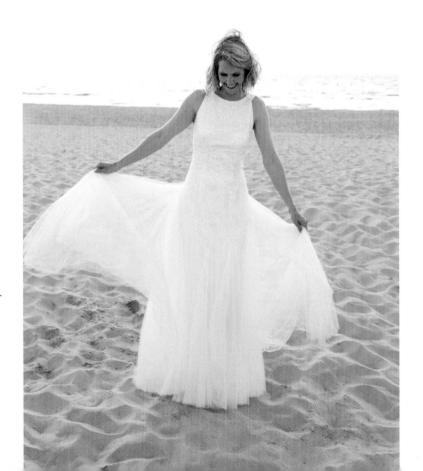

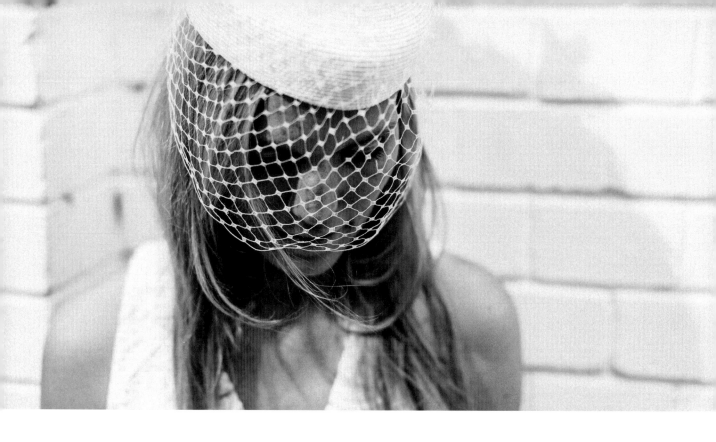

BEST ACCESSORIES FOR THE BRIDE

Whether simple and pure, romantically playful, or sparkling and elegant, you can personalize your outfit for the big day. Whether you wear lots of accessories or just a few, whether subtle or over-the-top, you determine the look. Here is a brief overview of the most important accessories for your dress.

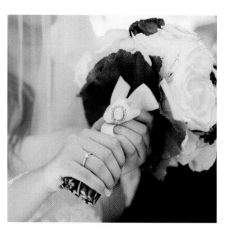

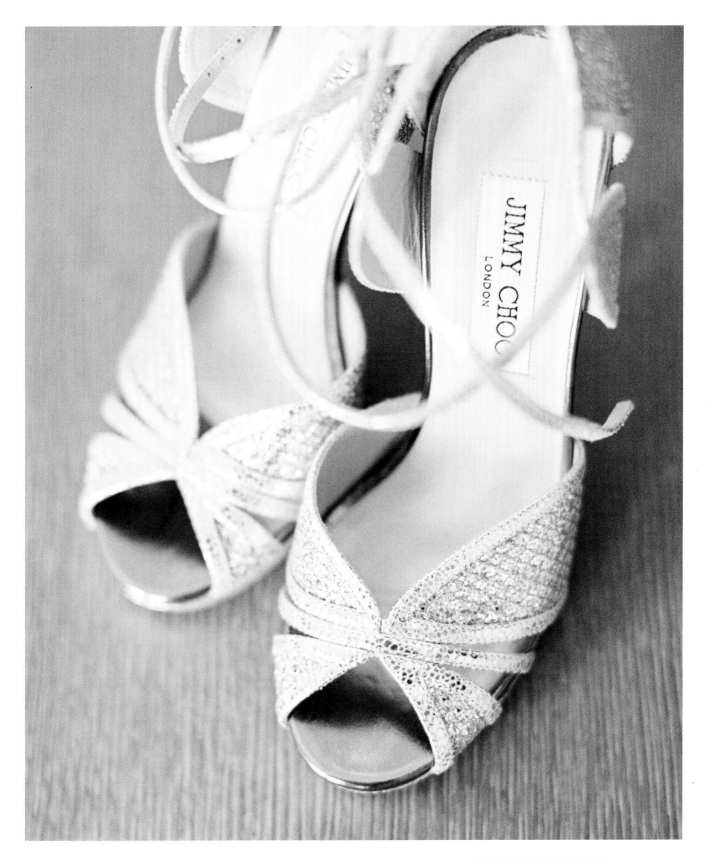

IT'S A QUESTION OF PERSONALITY:
Pay attention to the overall look
when choosing accessories

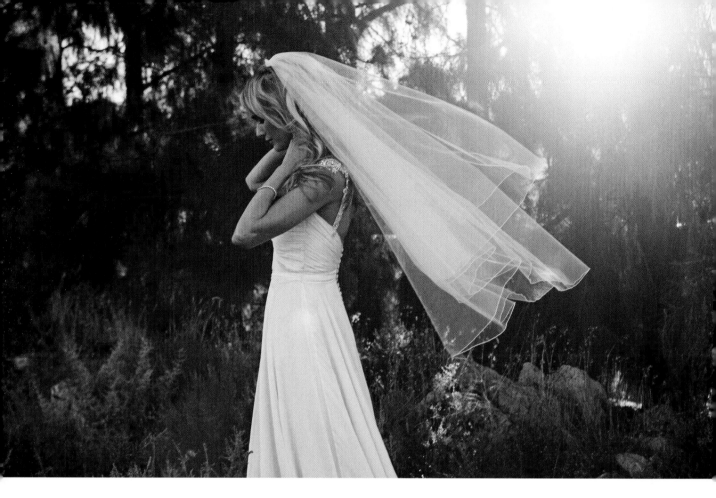

The Veil

The wedding veil is the most traditional part of the bride's outfit and predates the classic bridal gown. The popularity of the veil has varied over the course of centuries, and it wasn't until the 19th century that it became fashionable again. The veil is certainly one of the best-loved and most frequently worn accessories, and you will probably only wear one once in your life. For many brides, the first moment of overwhelming emotion occurs when trying on the veil for the first time. As with the white dress, it symbolizes purity and innocence. A bride hidden under the veil reflects the pure and innocent soul of a girl. For this purpose, most veils have a so-called blusher, which hides the bride's face and is only drawn back either when she is handed over to her husband or for the first kiss. In some countries and religions, though, the bride's face isn't concealed during the ceremony. Bridal veils are available in many different lengths, fabrics, and patterns. It is important, of course, that it suits both you and the style of your dress. Similar to dress silhouettes, there are many options when choosing a veil, and some of them can be very flattering and others are not. Short and wide veils suit delicate women well, while long, narrow-cut veils extend the figure and therefore work better for larger women. If your hair is worn up, the veil can be attached and integrated into the hairstyle quite effectively. If your hair is worn down, you should keep in mind that the grip isn't optimal and the veil can slide out easily. In this case, integrating the veil into a band of flowers is a good solution. If you don't want to wear a band of flowers, you could also have a braid made either from your own hair or from extensions. There are also hair bands that can be attached to the veil. However, it is

important to note that the veil should be taken off after the ceremony when in the receiving line, even if only temporarily, as many well-wishers will embrace the bride joyfully and firmly, which can cause the veil or hair-do to quickly become undone. Also keep in mind when making your choice that you should feel comfortable at the wedding and the fabric shouldn't restrict your freedom of movement too much; you would like to be able to move as elegantly and as easily as possible throughout the day. A veil that is constantly getting caught or is too heavy will soon become a nuisance and will no longer make you as happy as it did at the bridal boutique, where it floated over the soft carpet. In addition to the bridal bouquet and garter, traditionally the veil can also decide the next bride: Whoever snatches a piece of the veil and tears it off during the veil dance will, according to tradition, be the next to get married. However, this is an ancient tradition and fortunately it is only very rarely practiced nowadays, as it is a great pity to allow the bride's appearance to be destroyed by superstition.

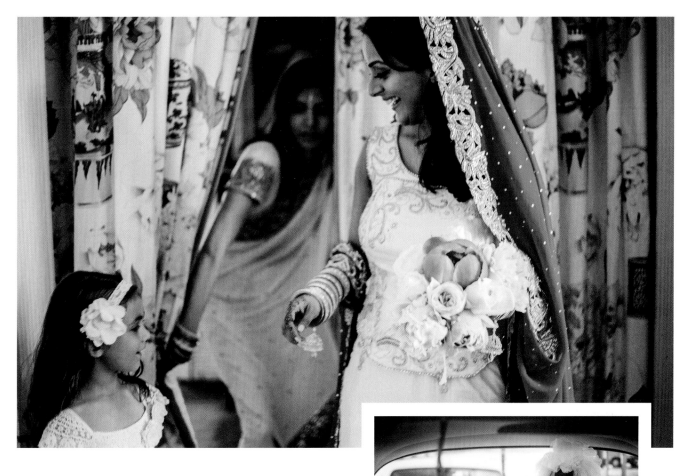

**FABRIC WITH
A LONG TRADITION:**

Bridal veils are found
in many cultures and
in a number of variations

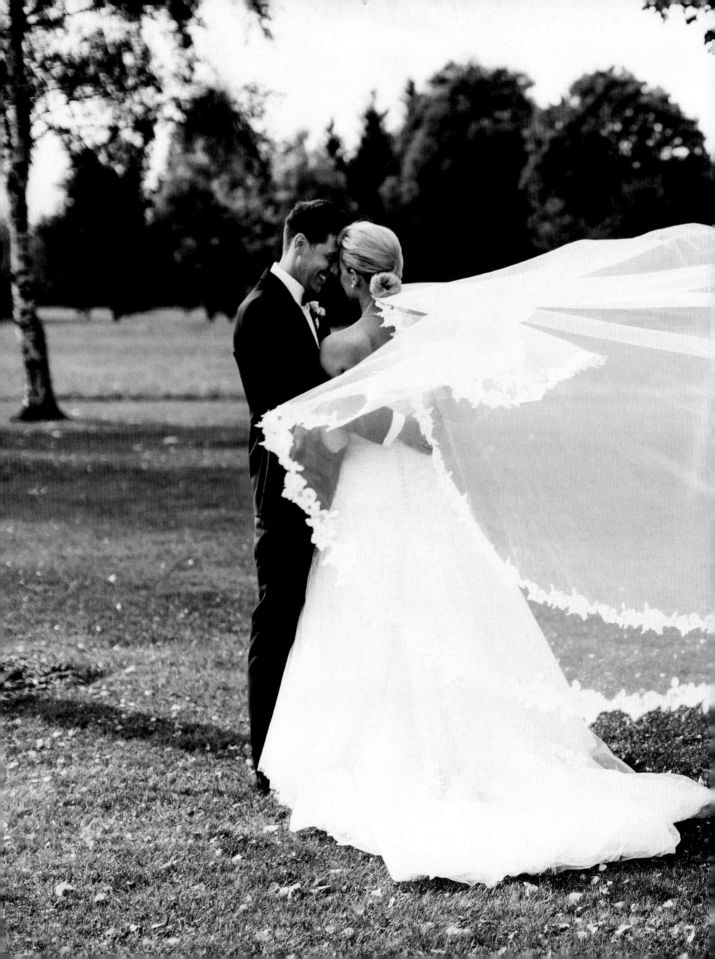

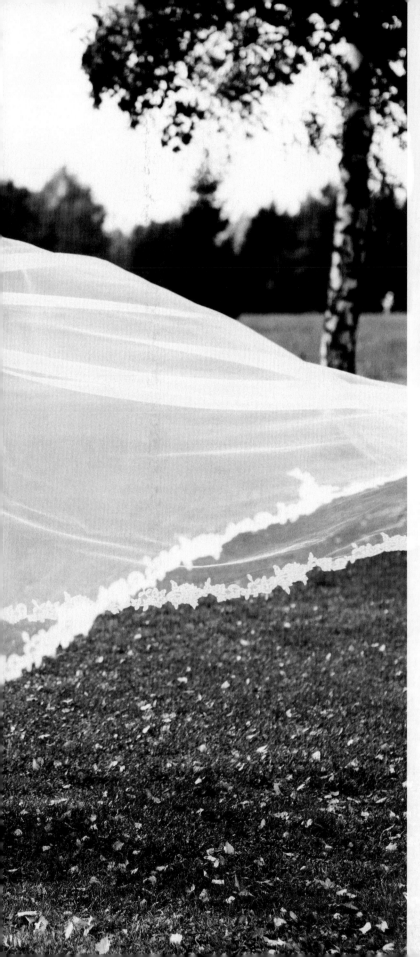

THE STUFF DREAMS ARE MADE OF ARE ALSO THE MOST POPULAR FABRICS FOR YOUR IDEAL WEDDING DRESS:

Lace:

A coveted good for centuries. Lace is available
in a wide variety of fabrics, colors, and patterns.
The pierced delicacy and semi-transparency are
what make lace such a favorite for wedding dresses.
Elegant, luxurious, and so fantastically beautiful.

Silk:

Whether flowing, shimmering, light,
or stiff. A wonderful material that allows
a multitude of looks to be created.

Tulle:

In the 19th century, the French town of Tulle
made this mesh-like fabric famous. Right up to
the present day, bridal fashion without tulle would
be unimaginable. It is also available as a stretch fabric
and can be made of natural or synthetic materials.

Satin:

Not all that glitters is gold. But it could be satin.
Smooth, shiny, luxurious. Whether simple or
decorated, it never fails to have the desired effect.

Taffeta:

Loads of volume, little weight, with a slight sheen.
Ideal for stiff skirts and structured dresses.

Silk-touch:

A great, inexpensive alternative to real silk.
Whether stretchy or not, it is washable,
easy to care for, and today, can barely be
distinguished from real silk.

Stretchy fabrics (silk, satin, etc.):

Stretchy fabric or inserts are a good choice
for wedding garments, as they ideally
accommodate freedom of movement,
eating, dancing, and long periods of sitting.

Chiffon:

A delicate touch, slightly transparent,
pixie-like. Chiffon also creates an airy effect,
especially as a top layer.

HEADDRESSES

*In addition to the veil, there are many other ways to adorn your head, frame your face, and complete the bridal look.
But headdresses aren't just popular for brides. They are also popular for guests. A wedding and the joy of
being invited to one is a special opportunity to really dress up, select an outfit that corresponds to the theme
of the wedding and the invitation, dress in style, so make an effort, and celebrate the festive occasion by wearing
a headdress. Here are a few ways to adorn your head, whether you're the bride or part of the wedding party:*

Fascinators:
Festive headdresses for female guests that are particularly worn in the UK. Arrangements made of fabrics, lace,
tulle, feathers, and flowers in all colors and forms. They are attached to a band or pin and appear to float
above the head. They are usually matched to the outfit or added as a festive splash of color for a more reserved look.

Flower garlands:
Primarily for the bride but also for your bridesmaids, flower girls, or witness. A charming idea
for guests, too, as long as they aren't too striking or similar to or outshine the bride's headdress.

A tiara (only for the bride):
A headdress that makes the bride queen for a day. Its crown-like appearance can make
a huge statement, but it must be stylish and elegant in order to achieve its purpose.

A chain:
Boho-style weddings particularly favor delicate chains attached to the hair,
dipping slightly over the crown and forehead.

A comb:
An old-fashioned comb is a wonderful way to keep your hair style in place and is also a lovely piece
of jewelry. Embellished or covered, it adds a pretty little eye-catcher to your hairstyle.

Ribbons:
Silk ribbons can find their way into hairstyles and onto ladies' heads
in many different ways. Why not yours?

Braiding:
Braids aren't just hairstyles, they are also headdresses. Innumerable braiding techniques
can offer fabulous, voluminous, old-fashioned, or modern flair and can reveal their full effect
with or without the addition of flowers or jewels.

Feathers:
Feathers are one of the most versatile things in nature because of their many forms and colors,
their lightness, and magic behind them. Feathers in hair are always beautiful.

A hat:
A hat, so desirable and appropriate, is always about attitude and the courage to wear it.
Although big hats are a little awkward, they are still eye-catching and a perfect accompaniment to a formal
outfit or dress. If the occasion presents itself and suits the style of the wedding ceremony,
it is worth being brave and having the courage to wear a hat!

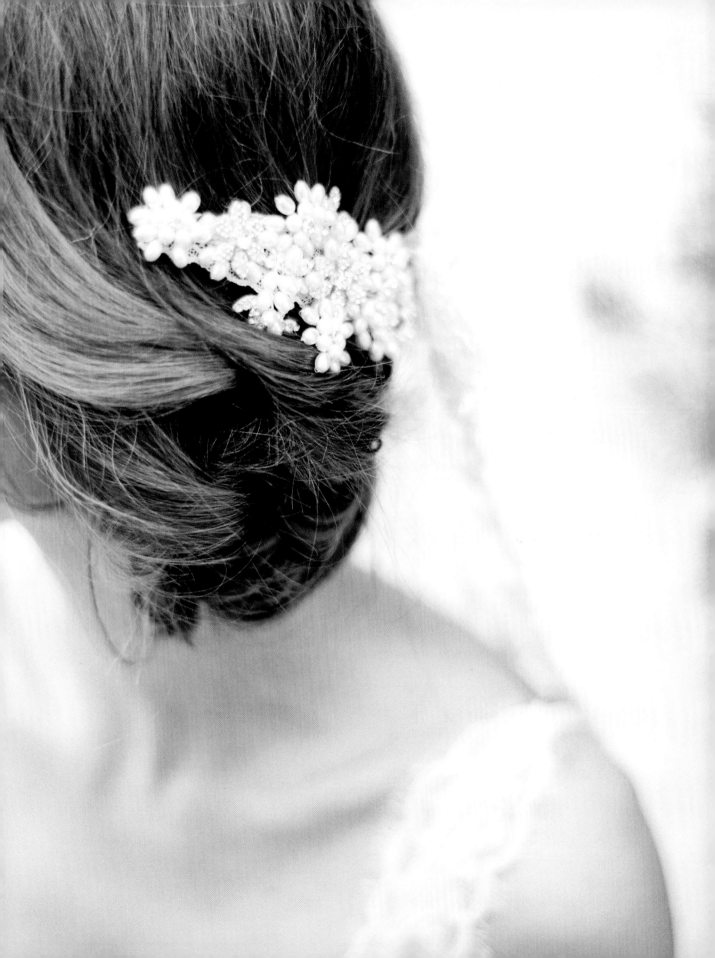

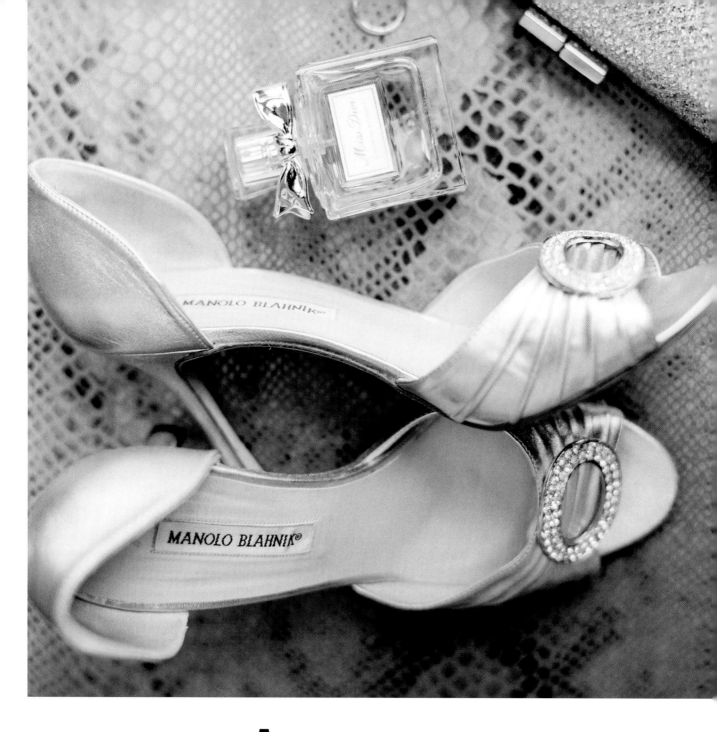

Don't
Step on
My Train!

A dress with a train really is quite special. This extra section of fabric changes the entire expression and silhouette—both yours and the cut of the dress. A train gently slides across the floor as a delicate insert at the back. Whether you want the kind that flows pixie-like from the back or more traditionally from the hem, the choice is up to you. If you do choose a train, it's worth deciding on one that can be either pinned up or detached. This will make your life easier, especially while dancing, and ensure that someone doesn't accidentally step on your train. You and your witness should practice pinning it up a couple of times beforehand to avoid constantly searching for tiny buttonholes for even tinier buttons during the celebration.

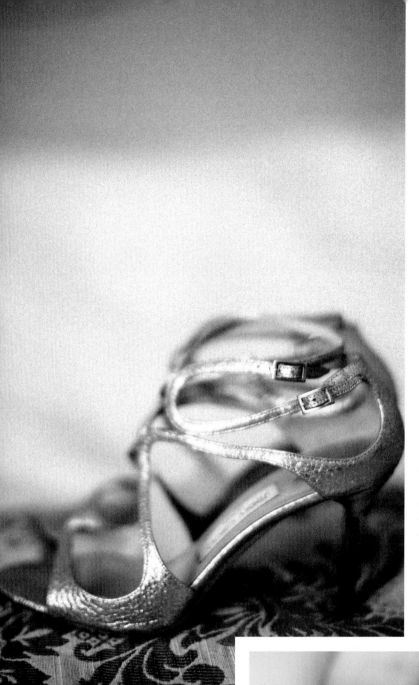

So that the shoe won't pinch— *the right bridal shoe.*

Whatever bridal shoes you choose, you should make sure they are comfortable. You will want to spend at least one whole day in them, stand a lot, dance, and look good in them without any irritation or pain. It is recommended that you carefully break in new shoes at home. If you are wearing a long bridal gown, you can easily do without heels, as the shoes will hardly be seen. If you want to wear high heels, think about the location of your wedding. Large lawns and bumpy cobblestones don't pair well with stilettos. Having a spare pair of shoes on hand is a reassuring precaution. This task can be delegated to the witness or bridesmaids.

Warning: Don't buy your shoes too small, as you will need a little room for air on a hot summer's day.

In the past, brides often paid for their bridal shoes with pennies they had been saving up for years. This collection was a symbol of frugality and suggested that they would also manage the household's money well in the marriage. Today, it is better to ask nicely whether a store will accept all of your loose change.

"SOMETHING OLD, SOMETHING NEW, SOMETHING BORROWED, SOMETHING BLUE."

A beautiful tradition for the bride that involves her family, mother, grandmother, and great-grandmother in the celebrations.

"SOMETHING BLUE, SOMETHING NEW":
Nowhere does it say that the bride's shoes must be white. Don't worry, there will be enough new things for the wedding.

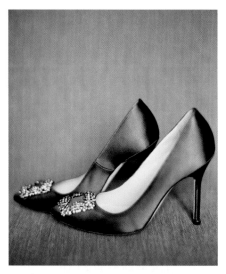

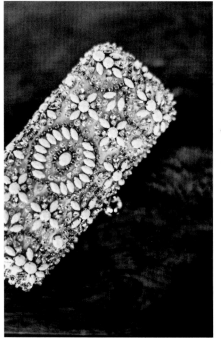

The custom of wearing "something old, something new, something borrowed, something blue" comes from Victorian England and refers to the bride. Today this custom is widespread outside Britain. In England, it is also customary to put a silver sixpence into the left shoe. The saying in English also rhymes with this: "Something old, something new, something borrowed, something blue, and a silver sixpence in your shoe." Often, "something old" is an inherited piece of jewelry, as this is supposed to be something from the bride's past. The jewelry is often passed on to the bride by her relatives on the wedding day. "Something new" is usually the wedding dress. "Something borrowed" should be an object that was used by another bride on her wedding day. The happiness of that bride is supposed to rub off on the current bride. The color stands for purity and fidelity. Traditionally, English brides wear a blue garter under their wedding dress. This is often joyfully thrown to the single female guests in the evening at the wedding reception in order to determine who will be the next bride, as is the case with the bridal bouquet. The coin in the bridal shoe is supposed to bring prosperity and financial peace of mind. If you would also like to practice this custom for your wedding, there is no harm in discreetly suggesting it to your maid of honor.

Congratulations! You have finally put your outfit together for the big day. But the most difficult job is still ahead of you. Not only do you have to keep your dress in the closet until the big day, you should, if possible, also keep it a secret—at least from your future husband. According to popular belief, it is unlucky if the bridegroom sees the bride in her wedding dress before the ceremony. According to an old superstition, the couple should ideally not see each other at all on the morning of the wedding in order to avoid the risk of the bridegroom canceling the engagement. However, this is one of the most unlikely things that could happen. So, don't worry. Today, the anticipation and surprise are the main reasons to meet at the altar. Hardly any moment is more emotional than when the excited bridegroom sees his bride in her dress for the first time walking down the aisle toward him. This applies in particular to church ceremonies. It's well worth biting your tongue and keeping the secret.

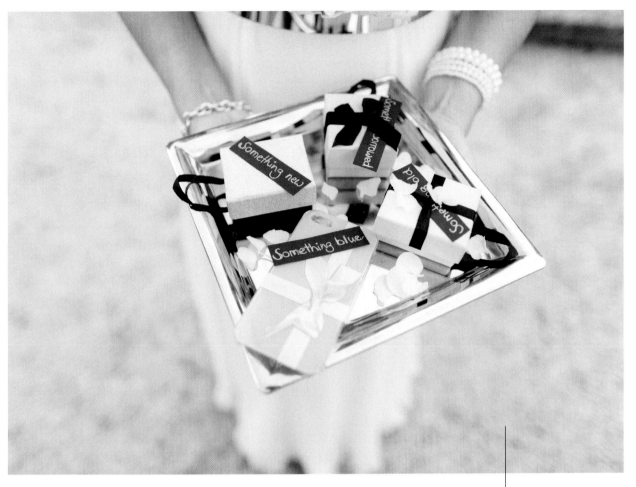

"SOMETHING BORROWED":
You can be a little more playful with classic traditions too

"SOMETHING OLD":
In many families, precious, unique pieces are passed on to the bride

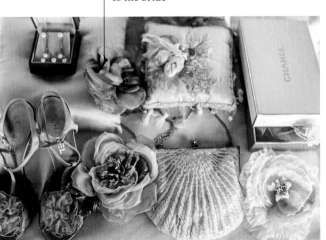

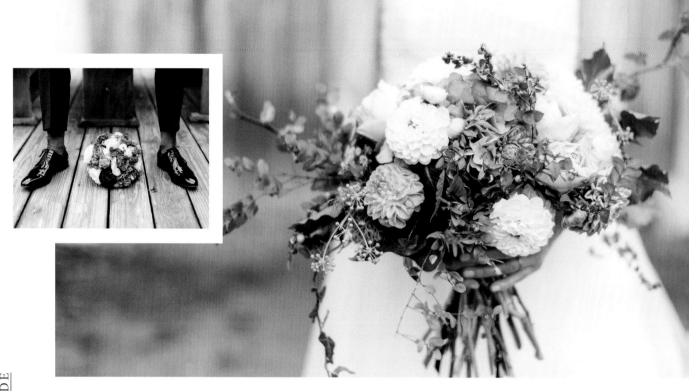

The bridal bouquet—
roses or wildflowers, tightly arranged
or loosely bound, the possibilities
are endless for this little gem.

The bridal bouquet, no matter how you design it, is an almost essential accessory. Flowers have always been a symbol of life, affection, and love. Virgins in Ancient Greece and Rome adorned themselves with flowers to please the gods of fertility. Originally, rosemary and myrtle were entwined into the bride's bouquet, as these plants were said to have special properties. In ancient times, rosemary was considered to be a holy symbol of love, as well as of remembrance and cleansing. The myrtle has evergreen leaves and develops red and white flowers that produce sweet fruit. It combines the symbols of permanence, stability, purity, passion, love, and beauty. Brides in Ancient Greece wore a wreath of myrtle wood. The most popular bridal flower, the rose, has always been a symbol of love. According to Greek mythology, Aphrodite, the goddess of love, was born from sea foam; white rose bushes grew wherever it fell.

Whatever type, color, and shape of flowers you choose depends on the season as well as on your outfit, of course. A harmonious result can be achieved by matching the color and style to the bridal gown and other accessories, such as the band of flowers or jewelry worn in your hair or on your arms and your make-up, as well as the table and decorations on the bridal car.

When choosing flowers, it's a good idea to choose what's in season—this reduces additional costs, prevents potential delivery problems, and sub-standard quality, and ensures the best visual result. You can research this yourself or ask your florist for suitable suggestions. There are many options regarding the style of the arrangement. The classics are the round clutch and cascade, which owe their names to their shapes. But looser, more natural arrangements are becoming more popular. Be careful not to use any colored elements; and if you are using stemmed flowers, have them removed to avoid unsightly marks on your wedding dress.

Traditionally, the bridegroom picks the flowers for his bride and brings the bridal bouquet with him. In order to respect this fine tradition without fear of the result, you might ask your future mother-in-law or your witness to help the bridegroom, which guarantees that the bride's wishes are respected. It is customary for the bride and groom not to see each other until they arrive at the ceremony. Therefore, the bridal bouquet is usually sent in the bridal car and delivered by the father of the bride or the witness.

The bridal bouquet attracts special attention from single female guests. The bride usually throws the bouquet over her shoulder into a group of single women. Whoever is lucky enough to catch it gets to keep it and, more importantly, will be the next to marry. However, many brides would prefer to keep their bridal bouquet as a reminder of their wedding day. In this case, you can have a second, usually smaller bouquet made. During the wedding ceremony, this can also serve as an additional accessory for the witness. If you would like to keep the bridal bouquet as a memento, you should hang it up by the stems to dry as soon as possible.

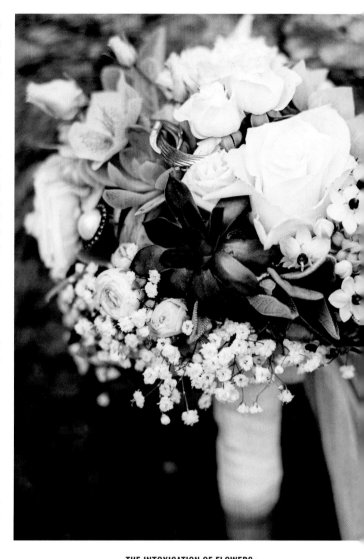

THE INTOXICATION OF FLOWERS:
Whether from the florist or a meadow, the bridal bouquet should go with your overall look

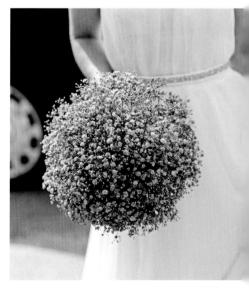

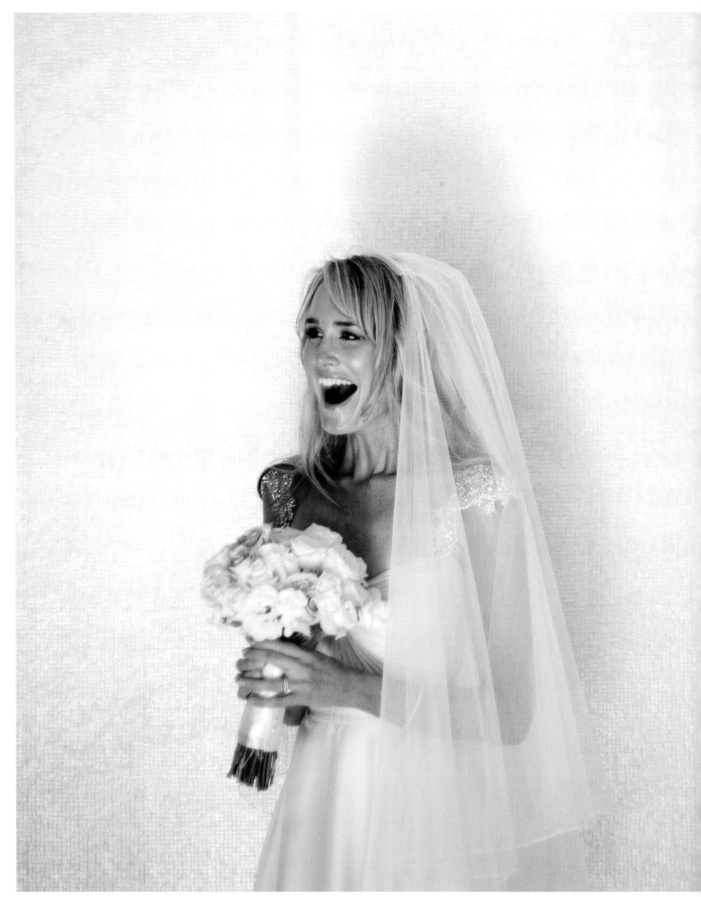

Getting Ready

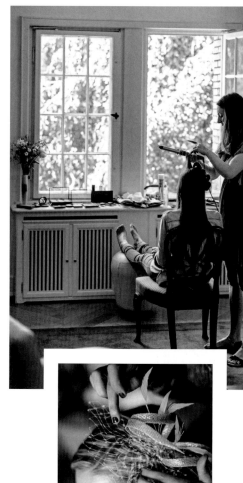

Take enough time on the day of your wedding to prepare for the ceremony. If you have booked a stylist, he or she is usually very well prepared because of the trial appointment, when you note how much time is required; they will be able to finish your hair and make-up within the scheduled time. However, complications or delays are always a possibility. It's best to err on the side of caution as you will be nervous enough already. Think about who you would like to have with you shortly before this great adventure. Give those you have chosen clear instructions and leave out anyone who will drive you crazy and is likely to make you more nervous. Overall, it is advisable not to have too many people floating around the bride shortly before things get started. Champagne and sparkling wine are often served when getting ready. Caution should be exercised here, however. Alcohol can have an unusually strong effect due to the immense excitement and the relatively small meal before the ceremony. And you want to fully enjoy this moment.

Important: Don't let your companions or a glance at the clock irritate you or throw you into a panic. All the people who are attending your big day, be it family, guests, or service providers, are there because of you. You can take as much time as you need and want. It's important that you feel comfortable and ready for everything, because all eyes will be on you. You should be able to enjoy the day without any worries—confidently, and radiantly. Just think of your bridegroom who is joyfully waiting for you.

GREAT EXCITEMENT:
Shortly before the ceremony. Moral and practical support are needed here

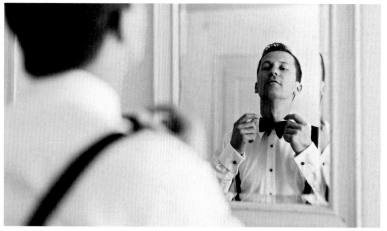

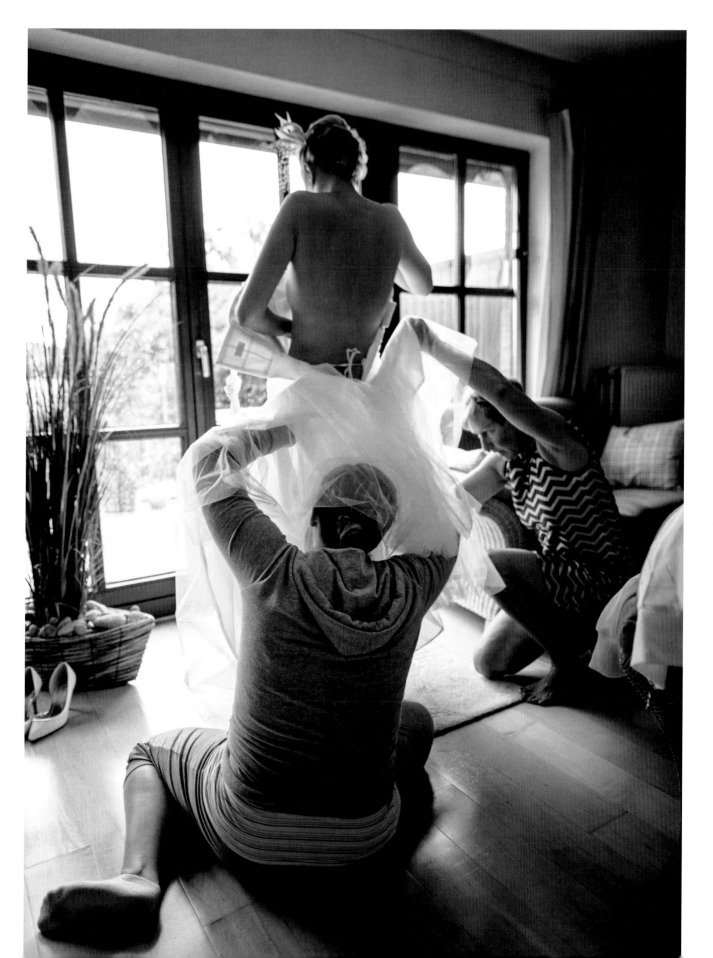

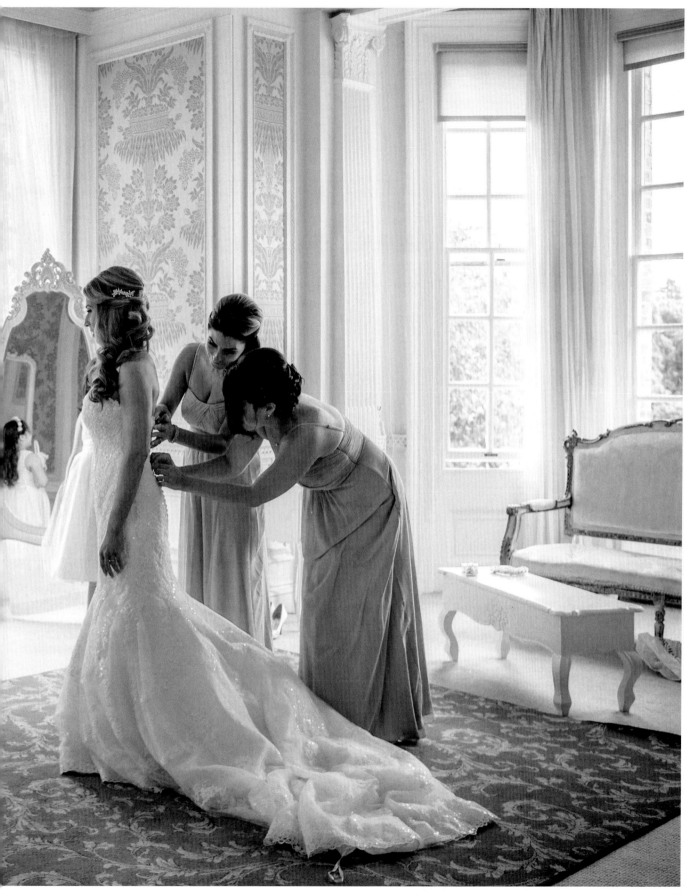

AND WHAT IS THE BRIDEGROOM GOING TO WEAR?

A suit is not just a suit.
For the most important man of the day, there are a great variety of outfits to choose from.

DETAILS, DETAILS:
Clearly, the dress code sets the tone and amusing little details make your outfit more personal and special

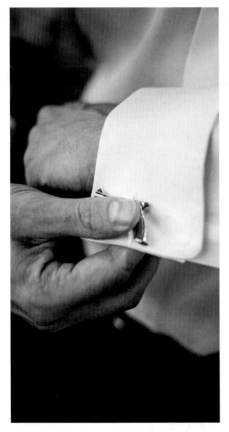

Just as the bride is overwhelmed by choices in her search for the perfect wedding dress, suits for the bridegroom are also available in a seemingly endless variety of shapes, colors, and cuts. How do you find the right suit? What applies for the bride doesn't, as a rule, apply for the bridegroom. The future wife usually keeps a sharp eye on the choice of clothing so that everything goes together in the end. You can't go wrong with a dark suit. For less formal weddings, pants and a blazer are a common combination. An iconic classic for the wedding ceremony and the celebrations afterward is the cutaway. The name means just that. This style was developed from the grand frock coat worn by 19th-century nobility. The front corners were simply cut away to provide more freedom of movement when riding. It is also referred to as a morning suit and is favored as the counterpart to a tailcoat. Not only is this nostalgic look very trendy considering how popular vintage wear is, it is also without a doubt the most elegant look of our day. The "cut" consists of gray/charcoal-colored striped pants and a gray or black jacket with tails. They can be worn with a white or colored shirt, vest (single or double-breasted), and a tie of your choice. An ascot can also be worn. Shoes should be matte-finish. Unlike other suits, such as a tuxedo, the cutaway is always single-breasted with one black button. Especially for weddings, the gray "cut" has become particularly popular, as many bridal couples prefer the brighter tone for their wedding instead of classic black. And a gray top hat can be beautifully combined with the cutaway. Again, if you have the courage to wear a hat, wear a cutaway. Wearing a bow tie with the suit—even though it is just as nostalgic nowadays—would not be a suitable match for the cutaway. At strictly traditional weddings, the groom wears a silk ascot and the wedding guests wear a silver-gray tie with a white shirt. The cutaway is a suit to be worn during the day, not the evening. Anyone who marries in this style changes into a tuxedo or tailcoat after 6 o'clock. This, of course, gives the bride an opportunity to slip into a second wedding dress for spirited partying into the early hours of the morning. The bridegroom, his father, closest male friends, and the best man usually wear a little flower pin on their lapel. This is called a buttonhole and shows that the man belongs to the bridegroom's team and is a particularly important person to the couple. It is especially beautiful and visually harmonious if elements and colors from the bridal bouquet are reflected in the buttonholes.

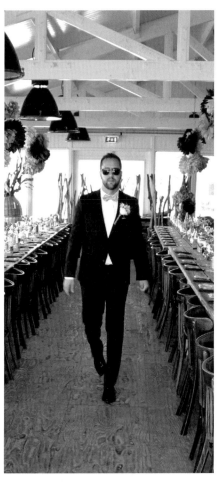

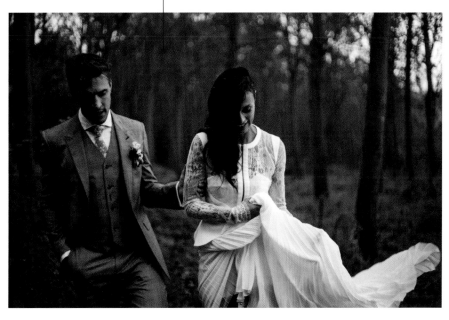

A QUESTION OF STYLE:
You should give careful consideration to how extravagantly you want to dress. Stay true to yourself.

STYLE-CONSCIOUS:
Classic gentlemen's accessories guarantee the perfect look

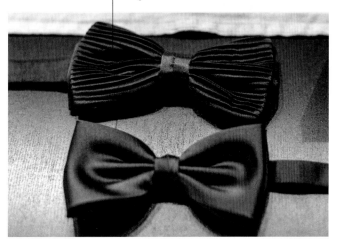

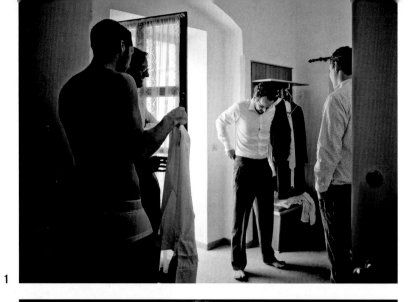

THE GROOM

Whether supported by your witnesses or not, *you should definitely discuss your outfit with the bride.*

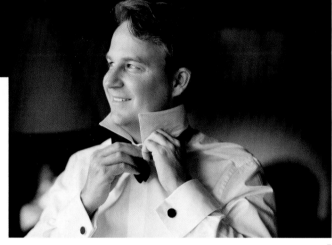

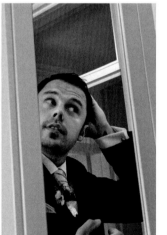

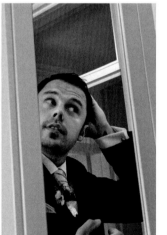

1 CHANGING OUTFITS:
Doing it together
is faster

2 MATCHING OUTFITS:
Make a real statement
at the altar

3 IN LOVE WITH DETAIL:
He's not just wearing
a black suit

4 PERFECT HAIR: It's not
just the ladies who think
getting the perfect look
is important

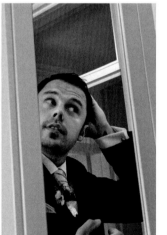

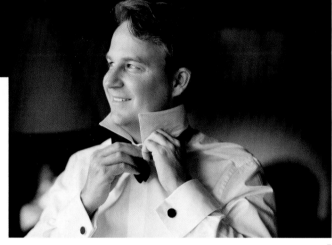

THE DRESS CODE

114

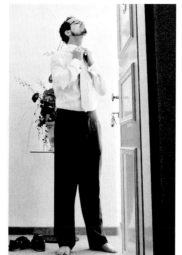

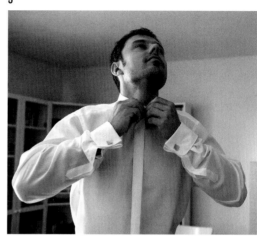

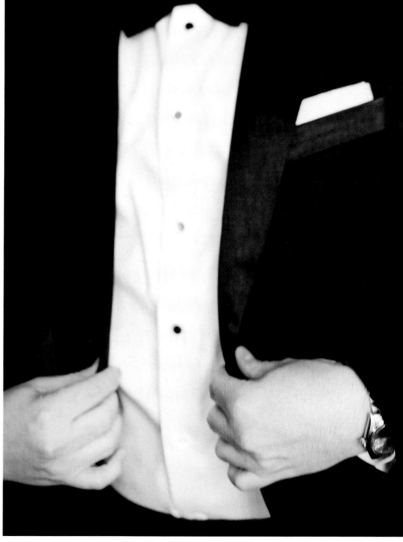

BLACK OR WHITE TIE?

The dress code
you choose
should also be
implemented down
to the last detail.

1 BEHIND THE SCENES: Time for some man-talk... **2** ...taking care
of the final details **3 CONCENTRATING** on the job at hand, until...
4 ...you finally get the right look

The Bridesmaids, Groomsmen, and Best Man

The tradition of having bridal companions arose from the desire to protect the bride and groom from evil spirits (what else?). That's why the bridesmaids' dresses are supposed to be as similar as possible to the actual wedding dress. Unfriendly demons then no longer know which of the ladies is the bride and can't inflict any evil. The bridegroom is protected using the same "trick" with the groomsmen and best man. Nowadays, however, carrying on this tradition has become a question of taste. The bride decides what her bridesmaids are to wear on her big day. There are three options: The simplest solution is that all wear the same dress. But if you wish to respect the individual attributes of your bridesmaids, we recommend that you choose three different dresses. The bridesmaids can either wear the same dress cut made in different fabrics or the same fabric in different cuts. The buttonhole is also an idea for bridesmaids instead of the traditional bouquets. The flower pins are less expensive and the ladies' hands are kept free when they accompany the bride to the altar.

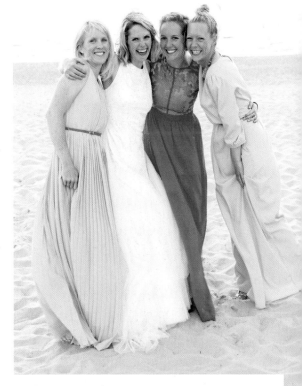

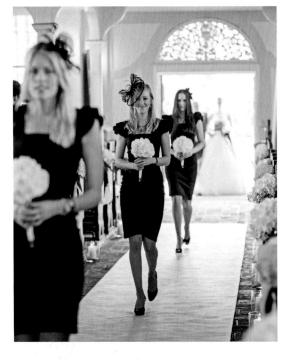

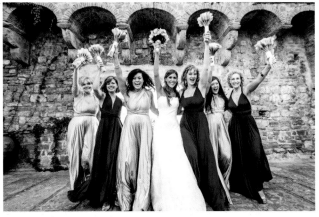

HERE'S TO FRIENDS!
Everything is easier together and the celebrations will be more relaxed

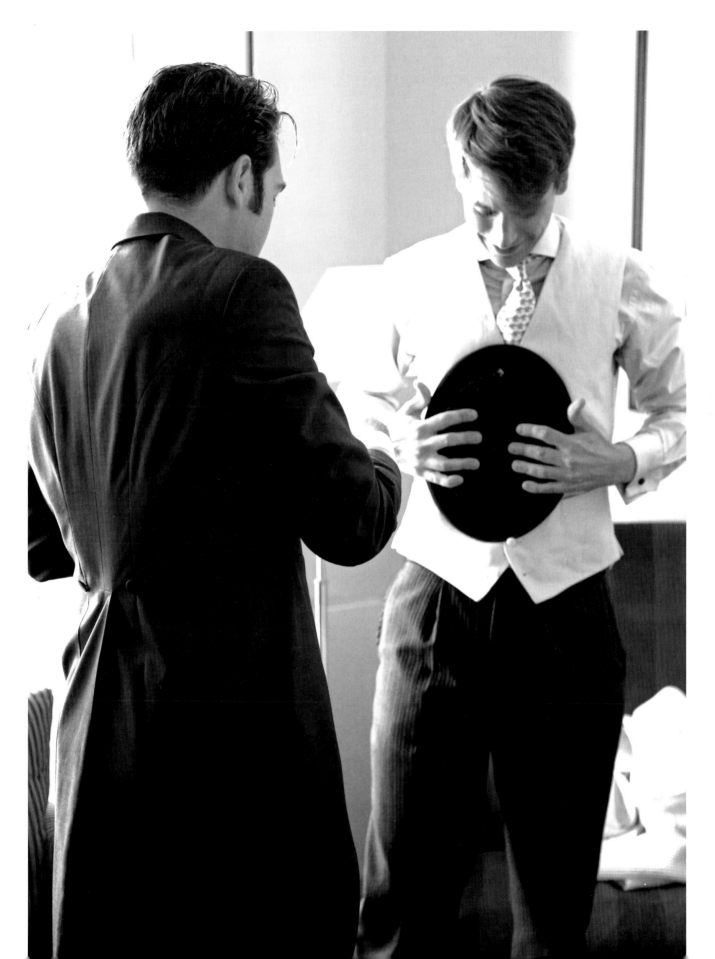

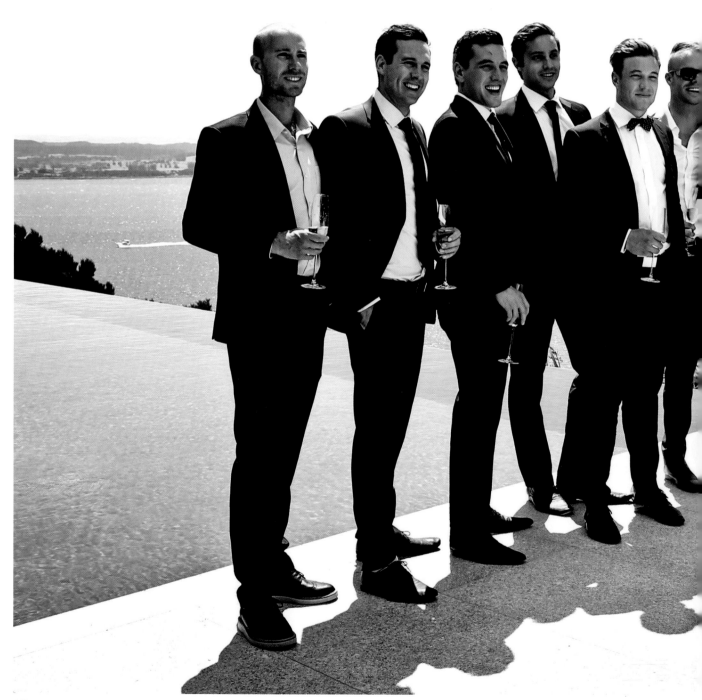

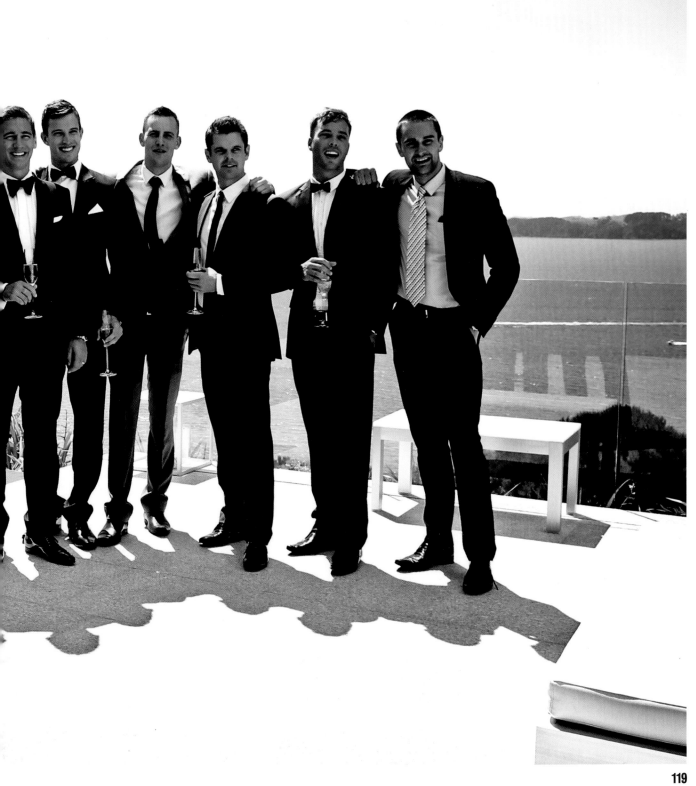

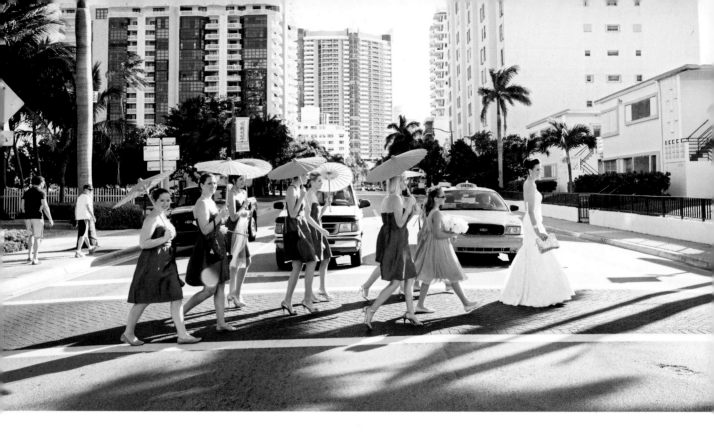

OUR PARTY,
YOUR PARTY—

celebrating with your best friends is the best way to party. It's nice if you can spend the day before or after together as well.

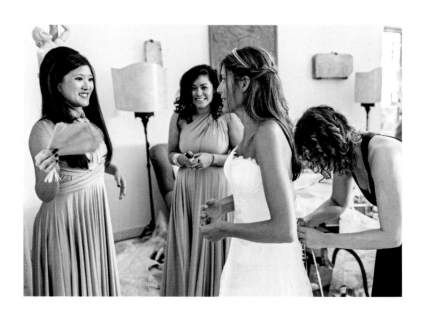

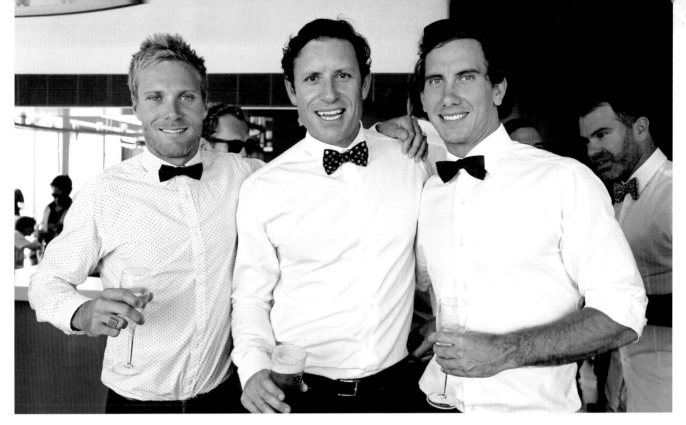

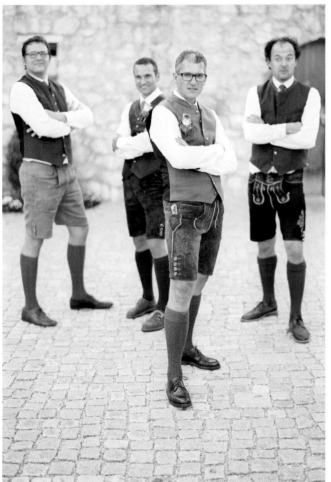

AN UNFORGETTABLE DAY:
for everyone who
was involved in the
planning and able to
celebrate with you

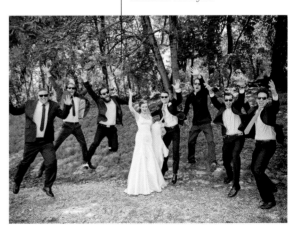

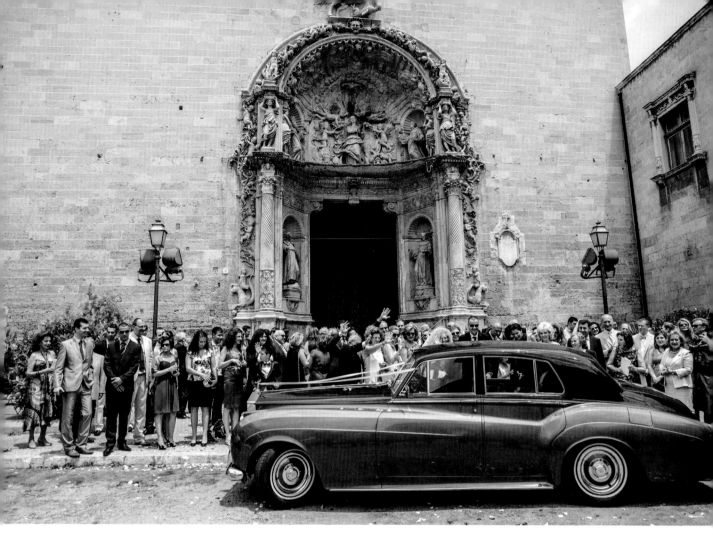

And the Guests?
A Little
Style Guide

It's fairly easy for guests to dress appropriately. There are only two rules. Follow the dress code on the invitation and never steal the show from the bride, so, no white or cream for the female guests. Men can't really go wrong with a dark suit. If there's no dress code, women can choose between a cocktail or an evening dress. For weddings in churches, the outfit shouldn't be too sexy or, at small weddings, they shouldn't be too dramatic. If you are unsure, it's best to check with the bridal couple or witnesses beforehand.

WHAT DOES IT ACTUALLY MEAN. . . ?

This is the way to decode information provided on invitations:

Formal:
Dark suits and cocktail dresses

Black tie:
Tuxedos and evening gowns

White tie:
Tails and long evening gowns

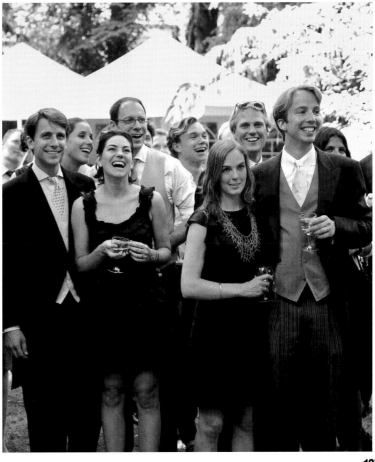

THE CEREMONY: THE HEART OF YOUR WEDDING

With all the planning—what to eat, what to wear, the look of the decorations—don't forget that this is the most important moment of the day. *Now it's just about the two of you.*

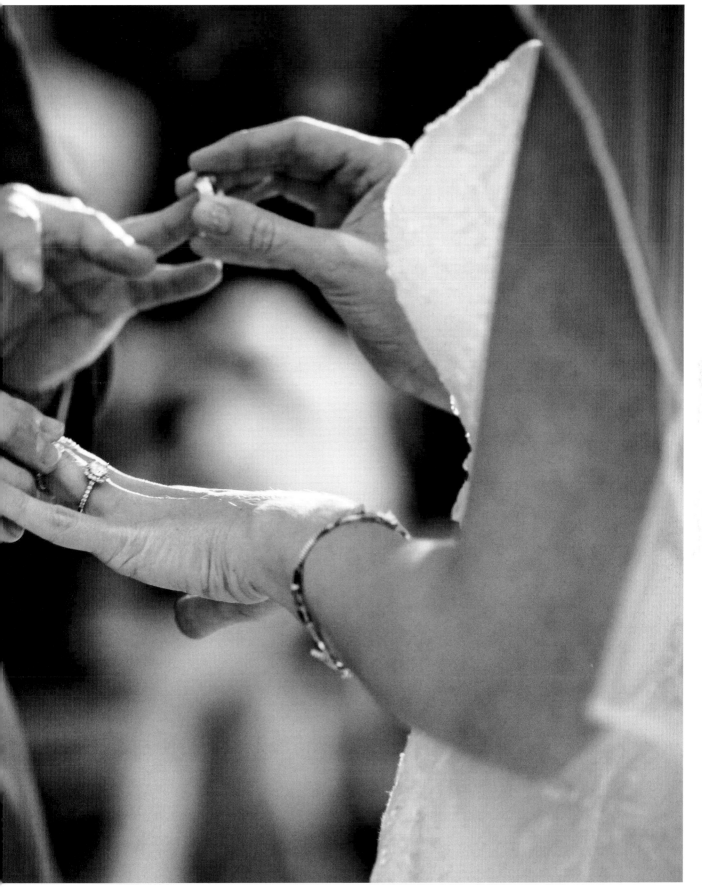

When people speak of a wedding, they are usually referring to the ceremony. This is the most important part of a wedding, the moment when the bride and groom are joined together as one. They can be joined together either before God in a church, or before the State in a civil ceremony. Some happy couples decide to have both, a religious as well as a civil ceremony.

TEARS OF JOY:
There are enough of these at such an occasion, nicely packaged help will find grateful hands

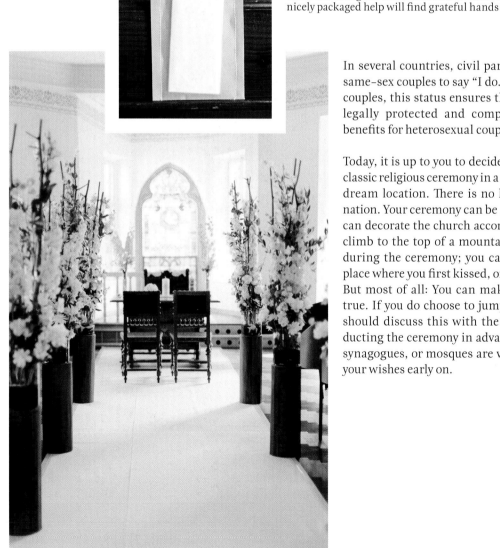

In several countries, civil partnerships also allow same-sex couples to say "I do." For gay and lesbian couples, this status ensures that their marriage is legally protected and comparable aspects and benefits for heterosexual couples.

Today, it is up to you to decide whether you want a classic religious ceremony in a church or one in your dream location. There is no limit to your imagination. Your ceremony can be held outdoors, or you can decorate the church according to your wishes, climb to the top of a mountain, or go swimming during the ceremony; you can also return to the place where you first kissed, or jump out of a plane. But most of all: You can make your dream come true. If you do choose to jump out of a plane, you should discuss this with the person who is conducting the ceremony in advance. Many churches, synagogues, or mosques are very flexible. Express your wishes early on.

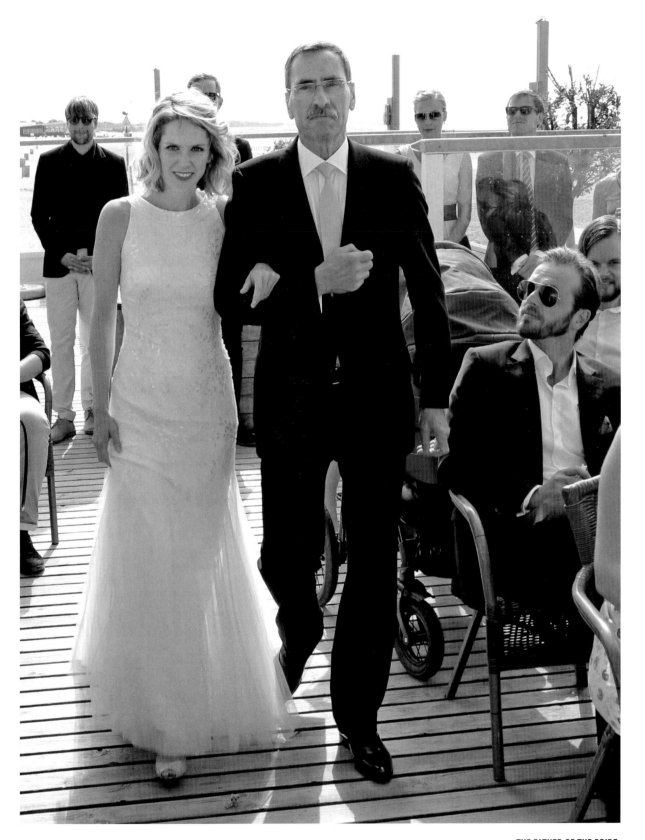

THE FATHER OF THE BRIDE:
An emotional moment and a wonderful appearance
for father and daughter

127

A secular wedding is also an option. A non-denominational wedding allows you to re-create the symbolic effect of a religious wedding—without the blessing of an established religious institution. You simply arrange everything exactly the way you want, without any restrictions. For example, if you want to get married at an altar, just set up an altar of your own. Look for an officiant and tell him what you want to hear from him during the ceremony and instruct him as to how he should conduct the wedding. The officiant is free to jump out of the plane with you, if this is really your dream. Secular weddings are becoming more and more popular. Individuality is the most important thing here.

A civil ceremony cannot be completely avoided if you want to be officially joined together as a couple. This ceremony involves a lot of official bureaucratic language. Because it's the State that joins the couple together in marriage, you don't have as much flexibility as you do with a non-denominational wedding or a church wedding. For a registry office wedding, it is particularly important to learn about the necessary and official documents you have to submit in order to be allowed to officially register the marriage with the authorities and enjoy the associated privileges. Nevertheless, a registry office wedding doesn't have to be as dry and bureaucratic as a visit to the residents' registration office. Today, you are free to choose the registry office yourself and it's also possible to a limited extent to book the registrar at your preferred location. However, every special request involves extra organization costs and should be initiated at an early stage. A civil ceremony also provides you with several options. You should just decide at an early stage what you want and how much you want it in order to be able to work out the budgetary framework that you want to maintain. Whatever you decide, start planning the wedding ceremony early.

The way you want to seal this life-long union is, of course, entirely up to you. As you can see, almost anything is possible. It is important that you feel comfortable with your choice, whether it's a church wedding, a civil ceremony, a secular ceremony, or registered civil partnership.

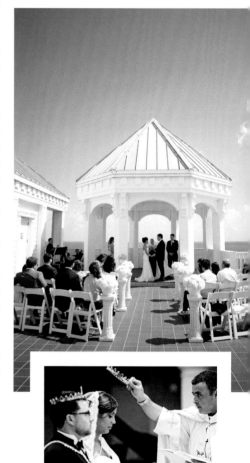

PROFESSION OF FAITH:
However and wherever you get married, find out early on whether your ideas are feasible

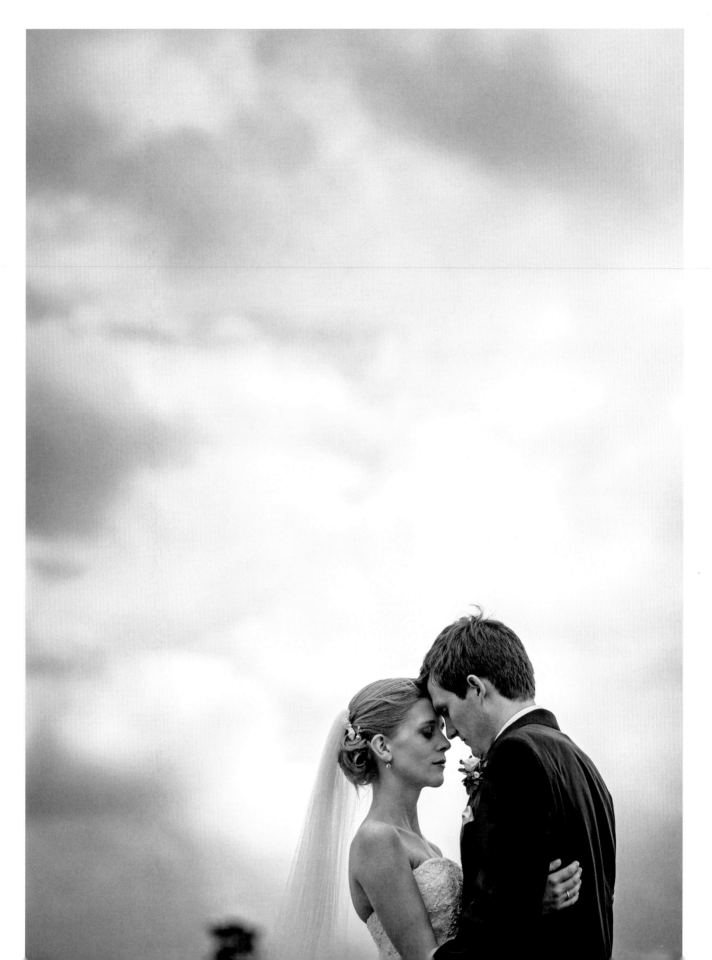

A CHECKLIST TO ENSURE EVERYTHING RUNS SMOOTHLY

Here are a few useful tips:

Whether you choose a church or civil ceremony,
be sure to book your desired date early on (at least
six months in advance). Some locations can be booked out
a year ahead, especially in spring and summer.

Take care of all the necessary papers
and documents on time.

Warning: Some documents required for marriage are certified
copies and have a shelf life of just six months. As soon as you
have these documents, you should send them to the registry office
of your choice in order to book an appointment
(which cannot be more than six months away).

At your desired location, ask about churches or venues
where the ceremony might be held and whom to contact about
booking them. It would be a pity to pay for an expensive
place to celebrate if the churches in the surrounding area
are not available.

Some churches and public offices, especially in rural areas
or abroad, only marry local couples or require a fee for the use
of the church. Others allow the church to be used, but don't
provide the priest or minister. So it's essential throughout
the planning to check the local rules and practices.

Ask about the options regarding the musical accompaniment:
Can the church organ be used and is it in tune? Is there
a local choir? Can music be brought along?

As a precaution, ask about renovation work, appointments
immediately after yours, and anything else that could interfere
with your celebration.

Can decorations be attached to pews and chairs and are there
any rules or prohibitions?

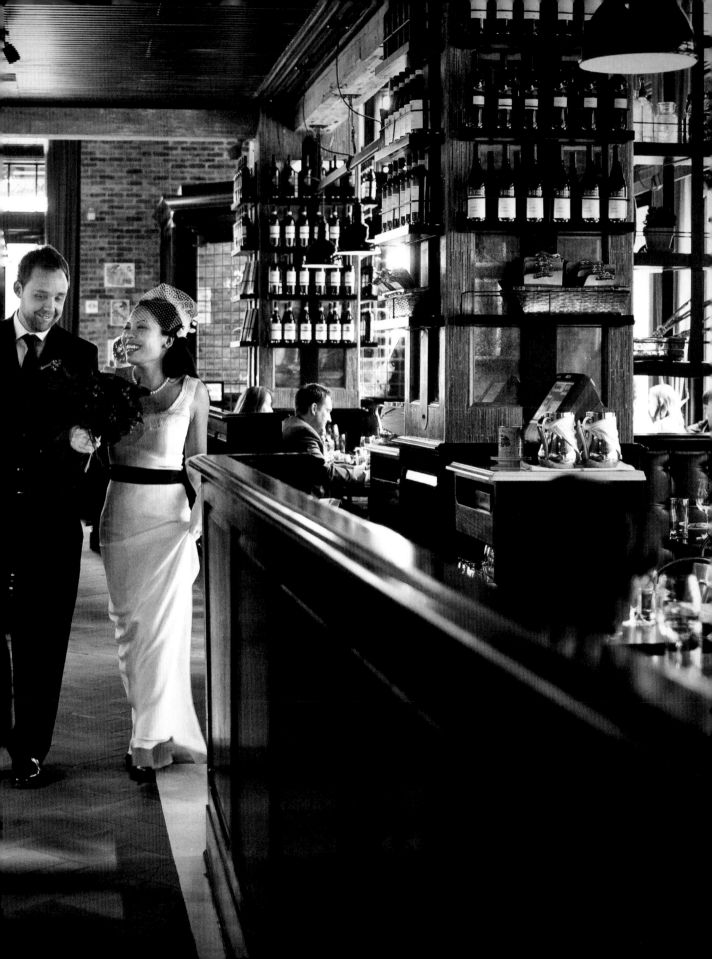

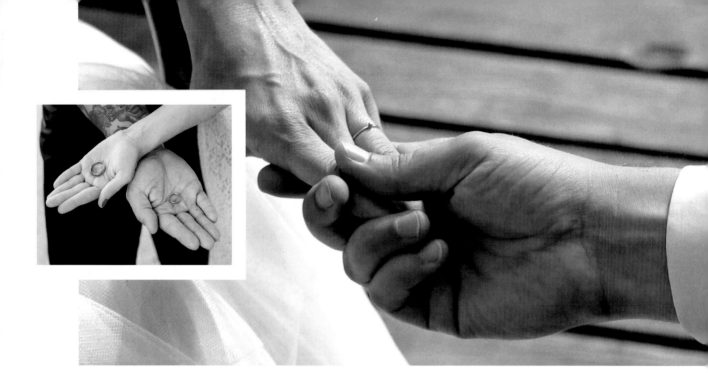

A Small Detail
of Great Importance:
the Wedding Ring.

Rings may be small in size but they are very important. After all, they are what seal the day and will adorn your hands every day as a visible symbol of your union. The phrase "look before you leap" doesn't only apply to your partner, but also to this very special piece of jewelry.

Rings have been around for ever. Due to their "infinite" variety, rings have been regarded as mystical and magical symbols. For example, in Ancient Rome men gave their brides a metal ring of keys as well as finger rings. In Southern and Central Europe, engagements were sealed by exchanging rings beginning in the High Middle Ages. The exchanging of rings gradually moved away from the engagement toward the wedding ceremony. This gesture became such a serious and binding promise that in some cultures, young women were forbidden to wear a ring on their finger at all. In addition to classic wedding rings, in many countries it's also customary to give the bride-to-be an engagement ring. Depending on the culture, wedding rings are worn on the right or left hand, sometimes together with an engagement ring to form a so-called combination ring. The classic engagement ring, a diamond solitaire, has prevailed as a symbol of eternal love and happiness. Lucky is the lady who can call one her own.

There are no limits to your imagination when choosing the ring. The usual materials are gold, silver, or platinum, glossy or matt, with or without stones. You can choose the rings from a jeweler you trust, have them specially made or, for something unique, you can even craft them yourselves. The same applies here: Enjoy this special occasion. Make an appointment with your partner and book an appointment at the jeweler's, so you can really look at everything, try the rings on and think it over. If you don't see one you like, don't buy one. If you aren't sure, sleep on it. No dealer of repute will talk you into buying something in a hurry. Choose carefully and consciously. Only then will you be happy with your piece of jewelry in the long run.

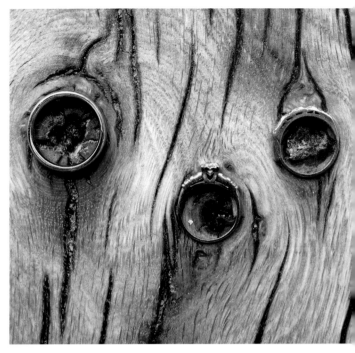

THE RINGS

Here are a few questions and tips for buying:

What should it be made of and
how much care will it require?

How much do you have in your budget?
It's best to decide on this together
before you go to the jeweler's.

Does the dealer provide certificates and services?
Cleaning, resizing, etc.

Ask about waiting and lead times! Not every jeweler
stocks every size. There may be waiting times,
especially in the spring.

Would you like it personally engraved?
This also takes time and must be completed
before the wedding.

The Wedding Vehicle

WELL MOTORIZED:
your first appearance
is always worth putting on
a little show

The wedding vehicle is important at most weddings. It can be driven by the father of the bride, a chauffeur, the best man, or the groom himself. It can be a horse-drawn carriage, a tractor, a vintage car, or a bicycle. Even if you want to push the bride to the reception in a wheelbarrow, it has to be decorated. Some popular adornments are "Just Married" signs, cans, shoes, bouquets of flowers, or all of these together. Traditional cans and shoes are supposed to keep ghosts and poverty away from the couple. Everyone enjoys hearing car horns honking and seeing the beaming newlyweds and their friends and families pass by. In some places, cans or large bouquets on the hoods are not allowed for safety reasons. If this is the case, decorations attached to the bumper are ideal, especially if you have a borrowed or hired car; their paintwork can go undamaged and the effect is just as impactful. Little bows for the guests' cars that can be attached after the ceremony, are cute.

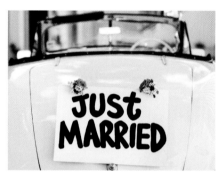

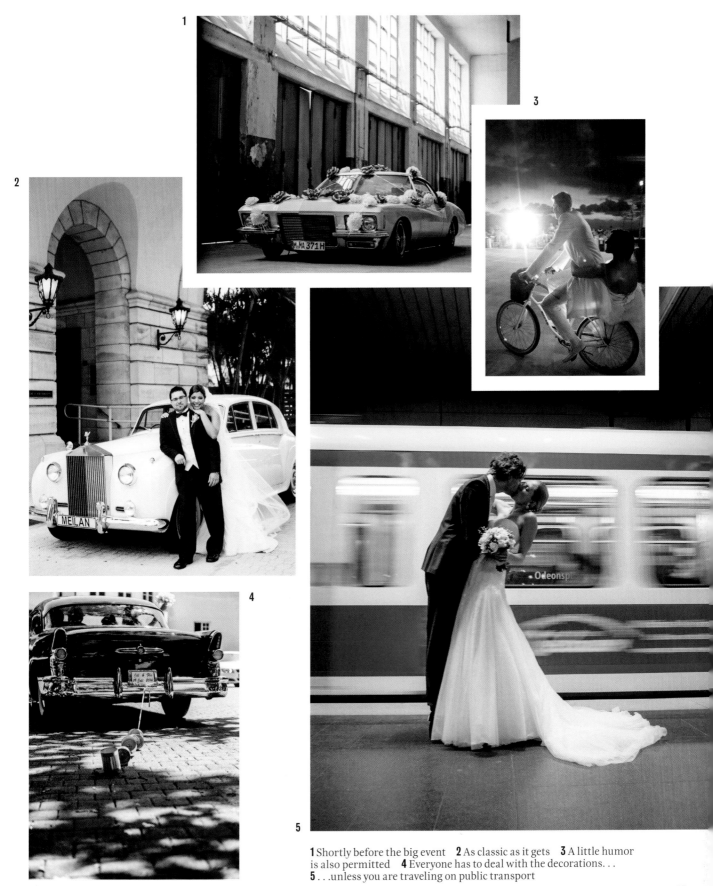

1 Shortly before the big event **2** As classic as it gets **3** A little humor
is also permitted **4** Everyone has to deal with the decorations. . .
5 . . .unless you are traveling on public transport

THE GREAT CELEBRATION

*Customs, music,
and speeches:*
everything to make
the party unforgettable.

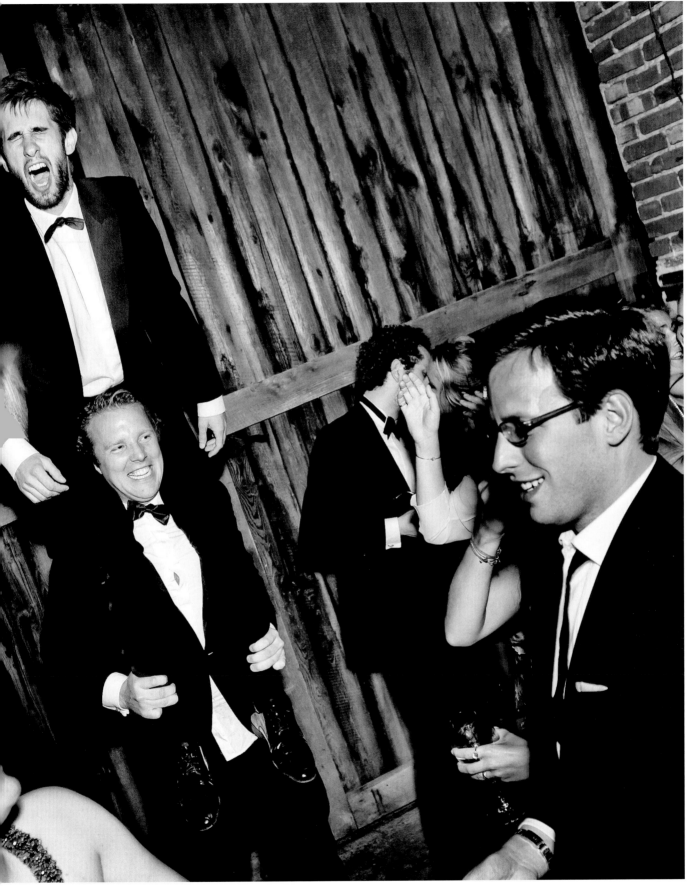

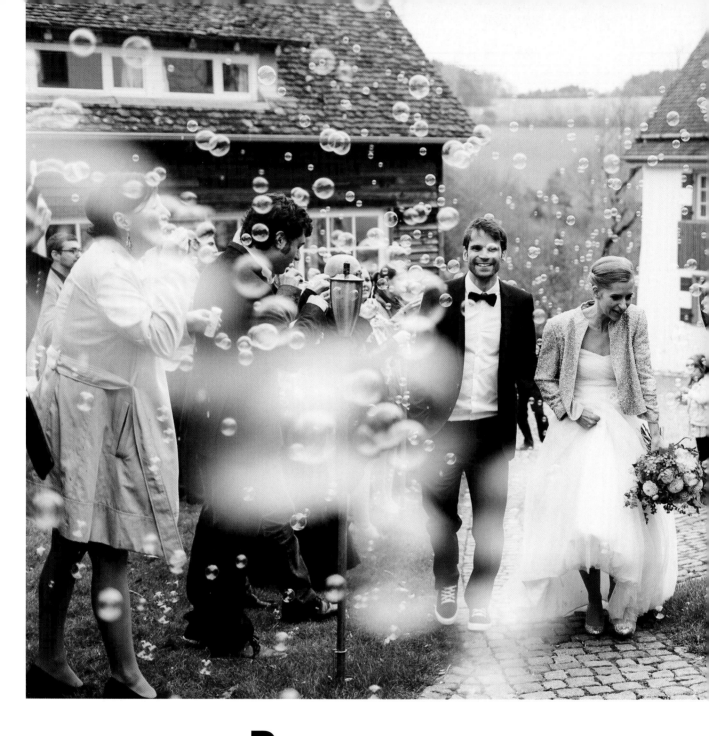

Let it Rain
Red Roses
For You

Rice is often thrown at the bride and groom as they are leaving the registry office or church. This is said to bring good luck and wherever the rice falls, the ground is said to be fertile. This custom is based on the English tradition of showering the couple with wheat or barley. If you feel sensitive about your hairstyle, please tell the witnesses well in advance, as the small grains will accompany you stubbornly throughout the day. Anyone who is reluctant to throw food around can gladly choose colorful or white confetti or rose petals instead, or just skip this tradition altogether. One lovely custom that's of special importance to the bride and groom involves wedding guests forming a guard of honor while holding roses, skis, balls, or whatever.

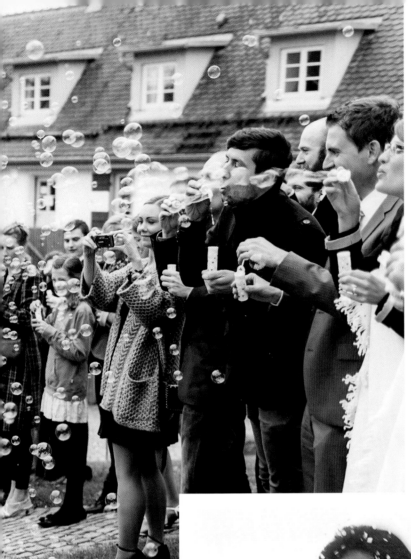

PLANTING A TREE

Many couples plant a tree together on their wedding day. On the one hand, the joint "work" is an expression of unity and, on the other hand, the tree and its growth symbolize the growth and prosperity of their marriage. Different trees have different meanings:

Oak

Oak symbolizes the permanence of the marriage. The oak is one of the strongest trees in the face of wind and weather. The marriage should also be resilient.

Willow

The willow represents magic and poetry in the marriage, as it has inspired many poets to write love poems. Earlier it was believed that the branches of the willow tree were good for preventing jealousy.

The Tree of Life

This is the name given to the Mountain Ash, also called the Rowan tree. It stands for a long life together.

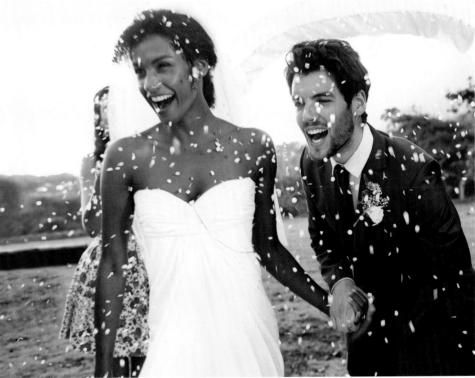

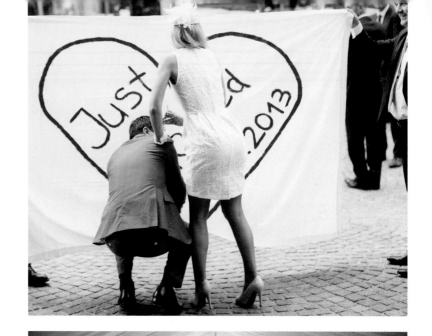

WEDDING CUSTOMS

When in Rome...
Almost every nationality
has its own wedding
traditions. However,
this doesn't mean
that you can't borrow
a few of them.

1

3

4

1 Unfortunately, balloons
are not allowed at every
location **2** For group
shots, you and the
photographer can get
creative **3** Every culture
has its own wedding
traditions **4** And not
all games are fun

2

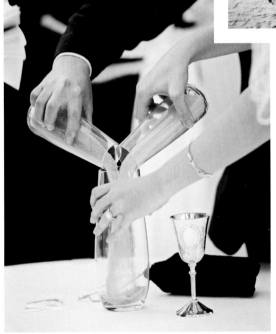

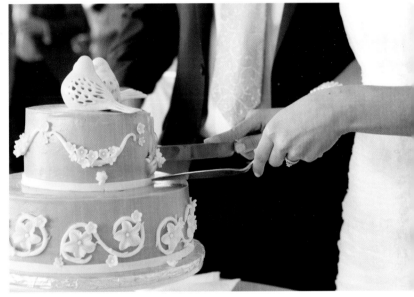

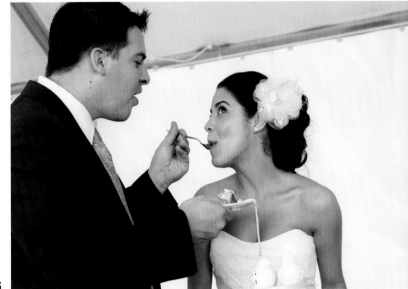

1 Stepping on a broken glass
is part of the Jewish tradition

2 Filling a jar with sand together
is a custom in the USA

3 But the wedding cake is cut
and tasted together everywhere

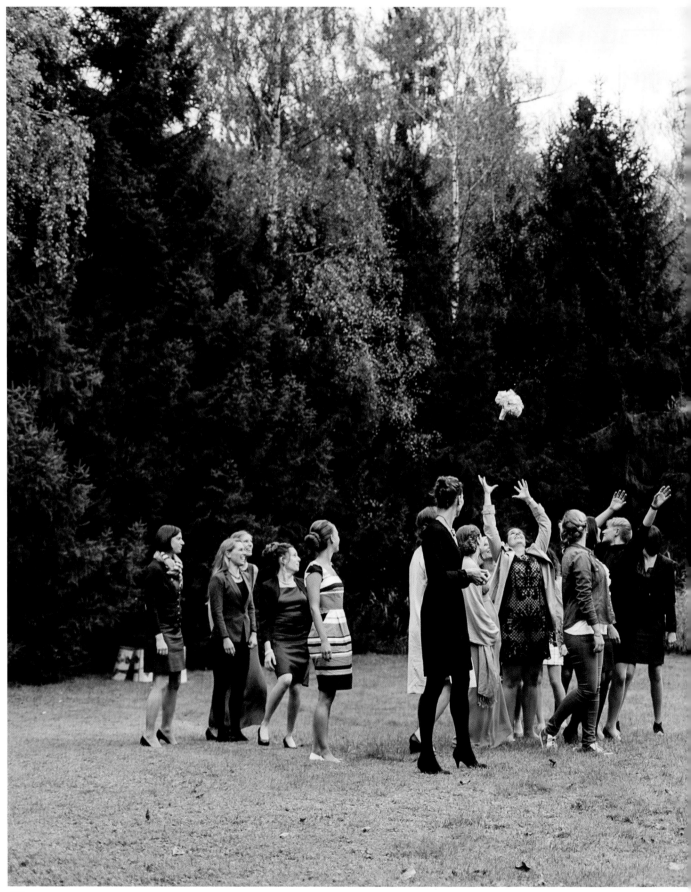

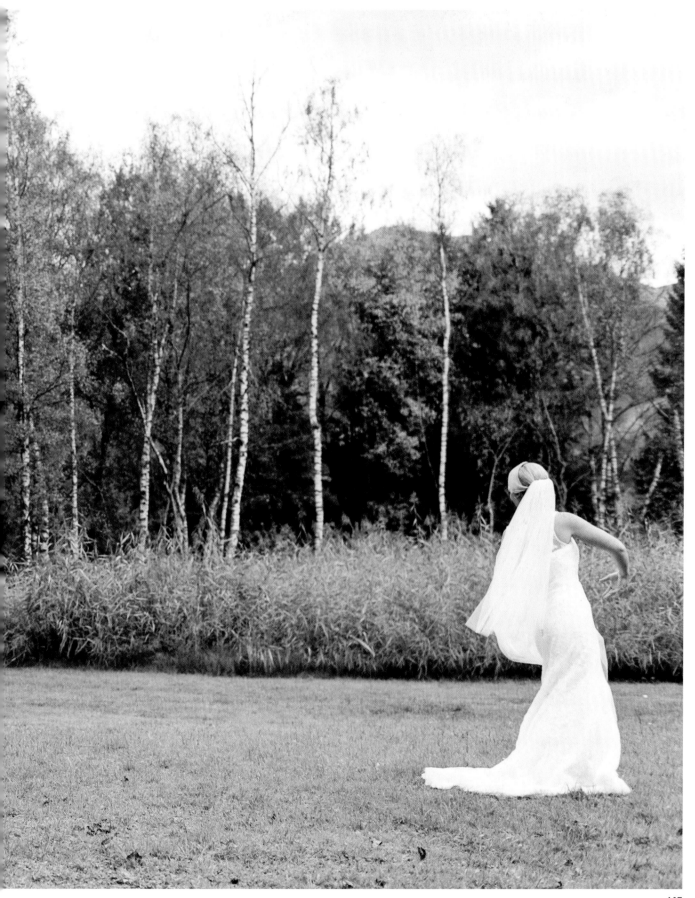

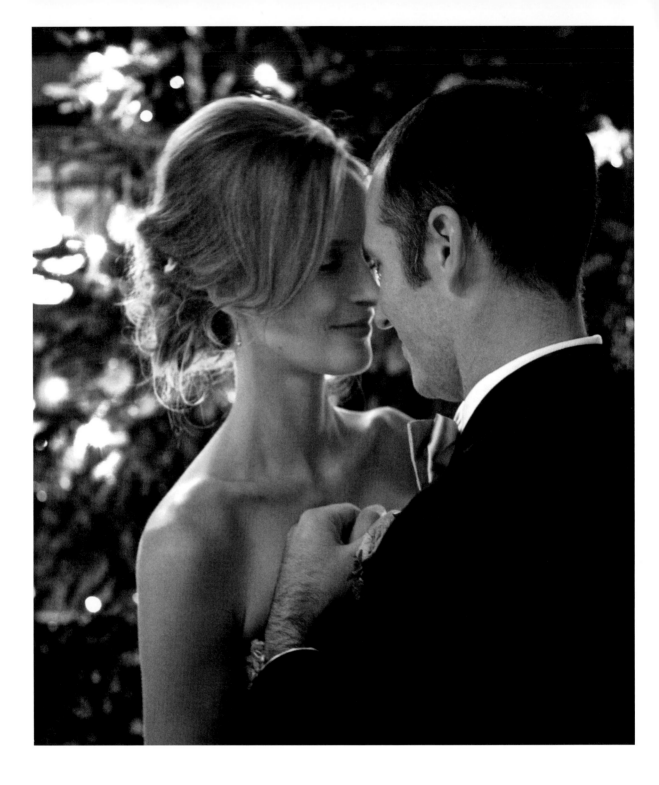

THE WEDDING DANCE

Traditionally, the bride and groom dance a wedding waltz. Today, couples also play their own very personal songs, and bring them to their dance lessons so that an experienced professional can help them keep in step. One of the nicest options for the wedding dance is a waltz played by siblings and friends as a lovely surprise.

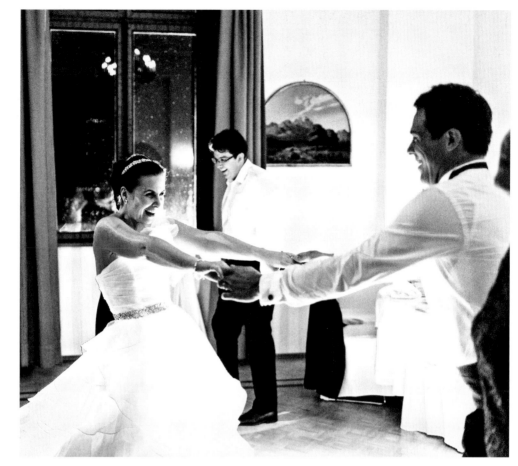

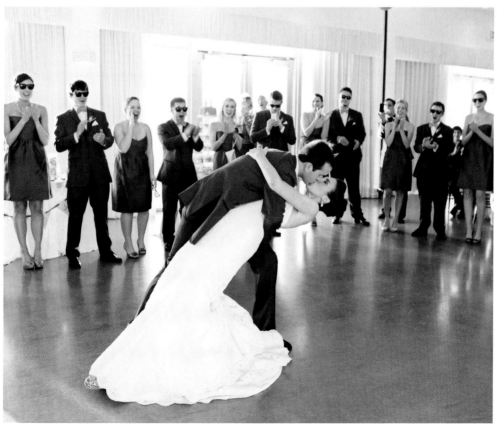

MUSIC AND DANCE

There is no party without music and this is particularly true for weddings.
But what kind of music? A band or a DJ? Rock or jazz? Imagine your celebration again.
What music would you like to dance to? What kind of celebration do you want to have
on your big day? Organize it accordingly. Whether you know a lot about music or not,
nothing prevents you from telling the DJ what songs to play or at the very least, what kind
of music you want to hear. Steer the music in your direction. It's your celebration. Your big day.
Everything is allowed here. A few points you should keep in mind:

A band can create a great atmosphere and really get the guests in the mood to celebrate.
However, many bands have a fixed repertoire and spontaneous song requests or
specific musical directions can be difficult to handle.

Good bands are booked well in advance and are expensive. Calculate the cost
of traveling to and from the venue, food, and drink for the whole team, transporting
the equipment, and possibly an overnight stay. Check the technical facilities on-site.

Musicians finish up much earlier than a DJ for a very practical reason:
At some point their vocal cords give up.

A DJ is far less impressive than a band, but will usually be a lot
less expensive and will play for a lot longer.

During the early stages of planning, clarify what kind of music you want. No-gos and
absolute must-haves and whether guests can request songs. These are things you decide.

The wedding dance absolutely must be arranged with the musicians or the DJ.

Discuss the mood you wish to create. The music plays
a significant role in steering the exuberance of the guests.

Think about the very young and old guests. It's a nice gesture
early in the evening to play some music that is suitable for everyone.

Get your witnesses to network with the musicians. At some point,
your friends will have a better overview of the planned contributions
and program points. It makes sense to discuss the music.

LET'S GET THE PARTY STARTED:
Whether a DJ or a band, whoever
provides the musical entertainment
should know beforehand what kind
of music you want to hear

PROGRAM AND ENTERTAINMENT

The atmosphere will take care of itself—well, maybe. But if you want to be on the safe side, here are a few useful tips.

Your guests have been well taken care of and now there is nothing standing in the way of an exciting celebration. The good news at this point is that the responsibility for the entertainment is not yours alone. Many of your friends, guests, and family want to contribute to the program. You should be sure the celebration remains yours. Brief the witnesses and those in charge in advance about the things that will make you happy and the contributions you would rather not see too much of. It's then the task of your loved ones to ensure that you get what you want and that several guests don't prepare the same contribution due to a lack of information. At this point, you can look forward to a number of nice surprises. Here are a few things that guests usually prepare for weddings:

GAMES, FUN, AND EXCITEMENT: Your guests are sure to organize a number of fringe activities, but you may also become quite active—for example, a photo booth always guarantees laughs and good memories

Speech, *Speech!*

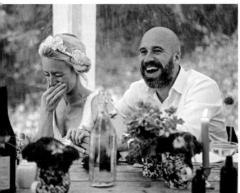

Whether you like it or not, it's unavoidable that some nice people at your wedding will want to speak about you. State on the invitation that speeches are to be agreed upon with the witnesses, who absolutely must coordinate speech times in advance with the caterer so that everything goes smoothly. The speakers should also be asked nicely not to take too long. As important and beautiful as speeches are, this is a celebration, and the festivities themselves shouldn't be too short. Long speeches can dampen the mood. Go by your instincts and gut feelings. The best speeches are short and simple.

Traditionally, the fathers speak first. Experience has shown that the speech by the witness is often the most convivial and amusing for the guests. It should come at the end in order to finish on a high note before the real celebration begins. The meal ends with a cheerful ambiance and at the speech's end the next part of the program—usually the couple's first dance—can be announced in a charming manner. It's generally best to use a microphone so that the speakers can be heard and any other announcements can be made clearly. Microphone checks should always be performed beforehand; otherwise there may be problems with the sound system. Nothing can disturb the romance of beautiful words as much as a cracking microphone or the beep of an incoming text message.

BEAUTIFUL WORDS:

Speeches are as much
a part of the celebration
as the exchanging of rings,
but clarify with the witnesses
who is to speak, when, and
for how long

Little Gifts Maintain Friendships.
Gifts and Mementos for Your Guests

Unfortunately, there is one thing not even we can change regarding your wedding: This day is over all too soon. Before you can blink, it has passed. The cake has been eaten, you have danced through the night, and all of the guests have said their goodbyes. What you are left with, in addition to the great partner by your side, are the beautiful memories and the wonderful moments. In order for you and your guests to have something lasting from your big event, here are a few ideas for how to extend the memory of your wedding to your loved ones.

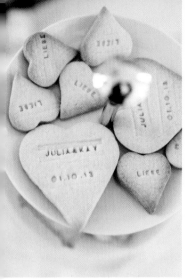

The Guests' Gift

Everyone remembers a successful wedding celebration, especially if there is a lovely little keepsake to take home. A small gift, waiting at the guests' seats or on the table settings, can be very effective. This will add to your guests' pleasure, and the unlimited possibilities when choosing the gift can even serve an additional practical purpose for your event. Traditionally, the custom is to give five sugared almonds. This tradition goes back to the time of the Sun King Louis XIV. At the court, these sweet treats were usually given away in valuable containers made of gold, silver, or crystal. Outside the court, a less expensive option was taking a piece of fabric cut from the wedding dress, decorating it with flowers, and wrapping the almonds inside. Wedding almonds are becoming more and more popular as a gift for guests. They are of great importance, especially in Greece and Italy. They are now available in many colors and decorative packages. The most common version is five white almonds in a white organza bag. Almonds are a symbol of life. Because life can be sweet as well as bitter, the slightly bitter almonds are sugarcoated. Five wedding almonds are given away because each represents a specific wish: health, wealth, happiness, fertility, and a long life for the bride and groom. Today, you just choose what you like best. In hot weather, for example, fans are a good choice that your guests will be very thankful for. Also providing simple flip-flops or espadrilles for tired feet can be a great contribution to the success of the dance floor, as many female guests will be only too happy to slip out of their uncomfortable high-heeled shoes. Bracelets are popular for ladies; handkerchiefs, badges, and cigars for gentlemen. "Hangover kits" are a nice touch and an especially welcome idea. These can await guests at their accommodation or can be placed on a side table or, depending on the size, at the guests' seats. Headache pills, the classic nighttime thirst-quencher, blister bandages, or a little lip balm are also pleasant treats. Chopsticks or chocolate drops can also be ordered and personalized, and can even be printed with your wedding date or a picture. Printed clothes pegs or a napkin embroidered with the name of the guest can simultaneously act as place cards. Be creative here; the guests are sure to be delighted with a small souvenir.

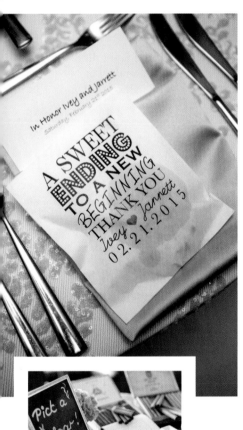

LITTLE KEEPSAKES:
Your gift to your guests does not have to be expensive; it should be a personal memento of your celebration. Ideally, it should fit in with the overall theme

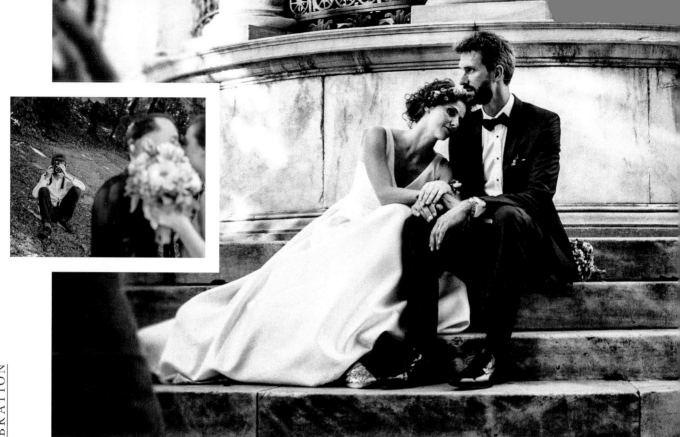

The Wedding Photographs

If you hire a wedding photographer, you should clarify beforehand which scenes should be photographed—when and where. Many couples meet before the ceremony to have photographs taken so all members of the wedding party can enjoy the wedding festivities. The same applies to all aspects of the wedding: The bride and groom must be seen, at the reception, the meal, and the party if the wedding is to be successful. If the wedding ceremony is held at noon, we recommend that the photographs be taken during the afternoon break instead of in the evening.

A professional photographer will accompany the bride and groom throughout the day and evening and will photograph everything. A great way to experience the wedding from the guests' point of view is to place disposable cameras on the tables or have a photo booth set up. This lets guests be creative and produces unforgettable moments. In the age of the Internet and smartphones, you can, of course, simply set up a personal hashtag. But be careful; these images are accessible to everyone on the Internet. You should consider beforehand how public you want to be.

THE GUEST BOOK AND VIDEO

Yes, you will find one at every wedding and it's not the most original idea, but: *It's simply wonderful to read or see messages from friends and family many years later.*

If you have a larger wedding party, a guest book is essential. Anyone who isn't put off by the cost and effort can install a camera with a timer in front of a special photo wall at the event hall's entrance as a special attraction. A photo printer can even be hooked up to print guests' photos on the spot. They can then be inserted into the guest book with a personal dedication.

As one of the biggest days in your life together, your wedding will have a place in your heart. You will regularly look back upon your memories, simply to experience the wonderful atmosphere and the associated feeling of happiness again. In addition to the obligatory wedding photos, you should consider whether you would like a video of the wedding in order to look back at your special memories. A wedding video allows you to immerse yourself in the celebrations again and again. By its very nature, a video recreates the atmosphere through moving images and sound in a way that is very different from still photographs. A video allows you to enjoy your wedding forever. It also allows you to discover scenes from your wedding that you missed during the celebrations, simply because you couldn't be everywhere at once. A wedding video is a dynamic medium for sharing your wedding with everyone at any time. Imagine your children or grandchildren asking about your wedding at some stage in the future, and you being able to re-live your memories through video. You and all of the viewers can become immersed in the moment of your wedding.

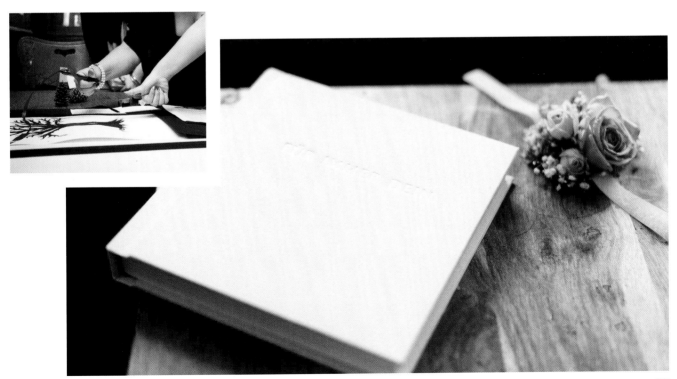

And then off
on the honeymoon. . .

Whether you set off while your guests are still celebrating, or three weeks later, your honeymoon is one of the high points of your marriage and gives you the chance to switch off, look back on the event, and enjoy yourselves to the fullest.

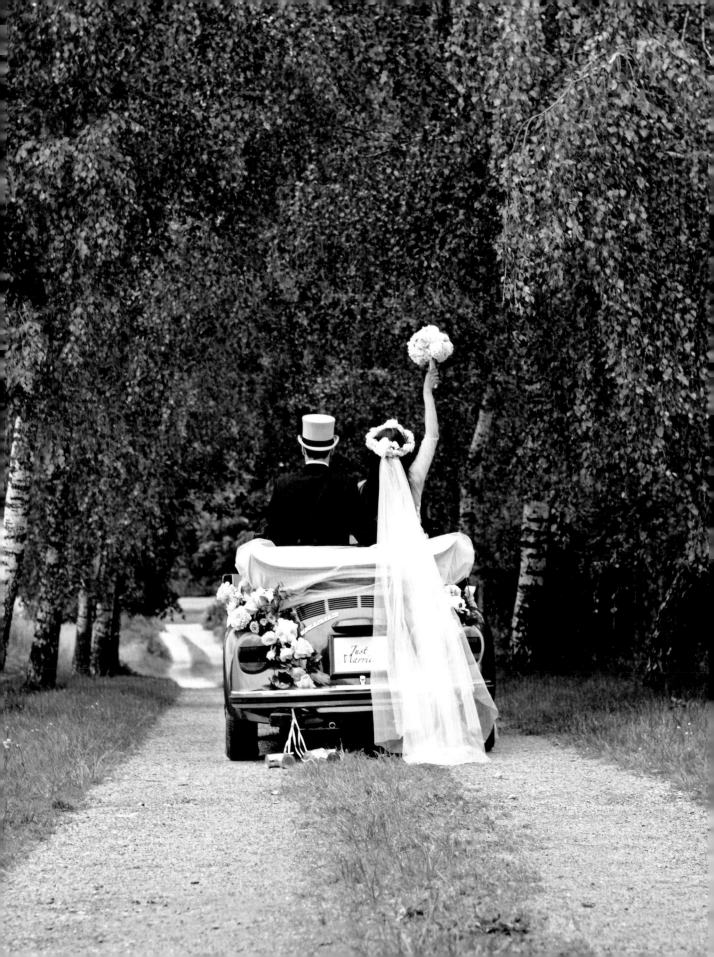

Photo Credits

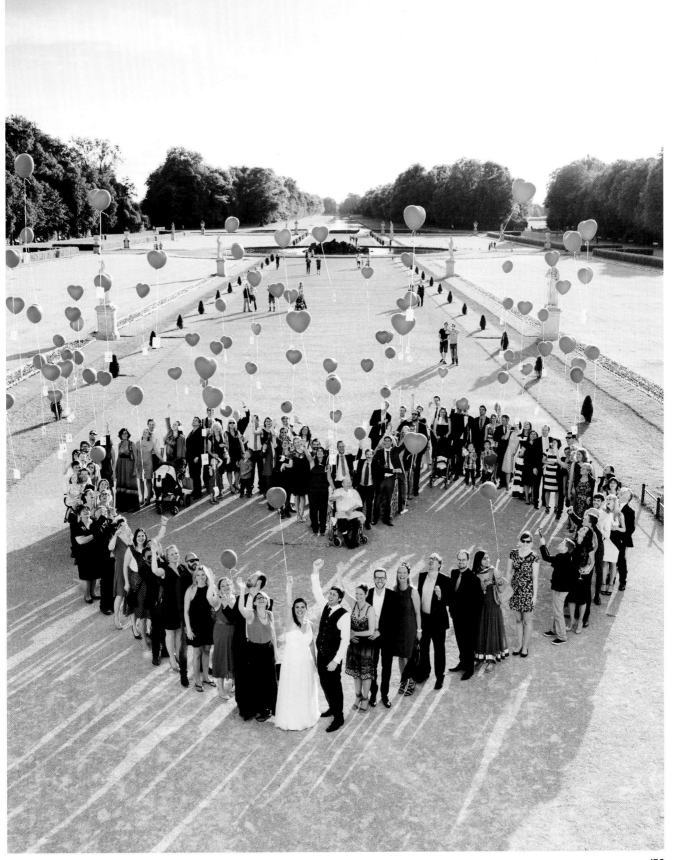

Acknowledgments

Creating this book filled us with great joy and afforded us a wonderful and emotional time
amid flowers, brides, tulle, and imagination.

We would like to thank our family:
In particular, our parents and our husband/brother-in-law Anthony, who helped us at all times with great commitment.
We would also like to thank Leonie Thelen and Sophia, Alice Menke, Linda and Amber, as well as Kim and Jan-Peter Heuer.

Further thanks to our friends and supporters:
Geraldine Calis-Laprell and Greta, Stella Reinke, Genia-Maria Karasek, Anne-Luise Hörr, Tanja Janta, and Oleg Justus, Nofretete Galliard,
Anjuta Buchholz, Ann-Kathrin Barthel, Princess Teresa of Sayn-Wittgenstein-Berleburg, Zoe Schlemmer, and Tanniløtta Heisler,
as well as Heaven's Gate Interior GmbH.

© 2015 teNeues Media GmbH + Co. KG, Kempen

Texts *Amélie Cremer & Carina von Bülow*
Art Direction *Patrycia Lukas*
Design *Saskia Ballhausen*
Layout & Prepress *Sophie Franke & Christin Steirat*
Editorial Coordination *Regine Freyberg & Nadine Weinhold*
Translation *Sprachwerkstatt Berlin, Laura Noonan*
Copyediting *Victorine Lamothe & Artes Translations, Dr Suzanne Kirkbright*
Production *Dieter Haberzettl*
Photo Editing *Regine Freyberg*
Imaging *David Burghardt*

English Edition *ISBN 978-3-8327-3302-5*
Library of Congress Number *2015940192*

Printed in the Czech Republic.

Bibliographic information published by the Deutsche Nationalbibliothek.
The Deutsche Nationalbibliothek lists this publication in the Deutsche
Nationalbibliografie; detailed bibliographic data are available on the
Internet at http://dnb.d-nb.de.

Published by teNeues Publishing Group

teNeues Media GmbH + Co. KG
Am Selder 37, 47906 Kempen, Germany
Phone: +49-(0)2152-916-0
Fax: +49-(0)2152-916-111
e-mail: books@teneues.com

Press department: Andrea Rehn
Phone: +49-(0)2152-916-202
e-mail: arehn@teneues.com

teNeues Publishing Company
7 West 18th Street, New York, NY 10011, USA
Phone: +1-212-627-9090
Fax: +1-212-627-9511

teNeues Publishing UK Ltd.
12 Ferndene Road, London SE24 0AQ, UK
Phone: +44-(0)20-3542-8997

teNeues France S.A.R.L.
39, rue des Billets, 18250 Henrichemont, France
Phone: +33-(0)2-4826-9348
Fax: +33-(0)1-7072-3482

www.teneues.com

teNeues Publishing Group
Kempen
Berlin
London
Munich
New York
Paris

teNeues